POSTCARD HISTORY SERIES

Bennington

Bennington

Bennington Historical Society and Bennington Museum

ARCADIA
PUBLISHING

Copyright © 2014 by Bennington Historical Society and Bennington Museum
ISBN 978-1-4671-2145-3

Published by Arcadia Publishing
Charleston, South Carolina

Printed in the United States of America

Library of Congress Control Number: 2012949426

For all general information contact Arcadia Publishing at:
Telephone 843-853-2070
Fax 843-853-0044
E-mail sales@arcadiapublishing.com
For customer service and orders:
Toll-Free 1-888-313-2665

Visit us on the Internet at www.arcadiapublishing.com

*This book is gratefully dedicated to all of our generous donors
who over the years have given the museum financial support as
well as the objects that make up our priceless collection.*

CONTENTS

ACKNOWLEDGMENTS

This book was authored for the Bennington Historical Society and Bennington Museum by Callie Raspuzzi Stewart, the coordinating editor and collections manager of the Bennington Museum; and Bennington Historical Society members Bill Morgan, Robert Ebert, Anne Bugbee, Joe Hall, Ted Bird, and Beverley Petrelis. A special thank-you goes to Hall and Petrelis, who generously shared postcards from their impressive private collections. Although they are too many to name, this book would never have been possible without the many donors who have given their postcards to the museum over the years. We are truly grateful.

Unless otherwise noted, images appear courtesy of the Bennington Museum.

INTRODUCTION

In January 1749, New Hampshire governor Benning Wentworth chartered Bennington, the first town grant in what is now Vermont, and named it after himself. He conveniently ignored the fact that New Hampshire's ambiguous western boundary was disputed by the Colony of New York. The town was not actually settled until 1761 when Capt. Samuel Robinson passed through the area on his way home to Hardwick, Massachusetts, after fighting in the French and Indian War. Robinson was so impressed that he bought up most of the town plots from the original grantees and led a group of settlers to Bennington on June 18, 1761, where they founded a congregational community based on membership in the only church in town.

The early settlers of Bennington and other towns in the New Hampshire grants soon found themselves in trouble with New Yorkers, who had been granted the same land by their Colonial governor. While politicians tried to settle competing claims through diplomacy, Ethan Allen and his band of Green Mountain Boys used vigilante justice to defend the land of New Hampshire grantees. The question was still unsettled when the Revolutionary War broke out.

British general John Burgoyne knew there was a Continental storehouse in Bennington, and as he marched his army south from Canada toward the Hudson River he found himself running low on provisions. He sent a small detachment to Bennington under Lt. Col. Friedrich Baum. New Hampshire troops under Gen. John Stark as well as the Green Mountain Boys and militia from Massachusetts were able to defeat the British in the Battle of Bennington, which took place on August 16, 1777, several miles west of town in New York. Failure to procure necessary supplies did not help Burgoyne's mission, and the British were defeated again at the Battle of Saratoga two months later, effectively ending the plan to cut New England off from the remaining colonies.

Like many small towns in New England, Bennington began as an agricultural community whose waterways were later dominated by large factories. Small mills for grinding grains and sawing lumber were among the first public buildings constructed to satisfy the early settlers' needs for food and shelter. These mills were later supplanted by factories that processed textiles both for local use and for export. The importation of merino sheep in the early 1800s gave Vermont a leg up in the wool industry, and wool continued to be a driving force in Bennington throughout the century. Mills manufacturing wool knit underwear were among the most successful in town. Other companies manufactured cotton cloth, paper, furniture, pottery, gunpowder, knitting machinery, toys, and novelties. Industrialization attracted immigrants from Europe, as well as French Canadians.

Manufacturing declined in the early 1900s as many companies moved their operations south in search of cheaper labor. While manufacturing struggled, Bennington reinvented itself as a tourist destination. Old Bennington had long been filled with summer homes of the Troy industrial elite. Automobiles and trains made the town easily accessible from the larger metropolis of New York City. Luxurious inns and roadside hotels went in and out of business. Monuments to events and people related to the Battle of Bennington sprang up to explain the town's importance to travelers and foster local pride.

The growth of tourism in Vermont coincided with a growth in popularity of the picture postcard. The United States Post Office Department approved the divided back postcard for mailing in 1907, meaning that half of the back side of the postcard could be used for a message, while the other half was used for the address. Before this, the entire back of the postcard was reserved for the address only, and messages could only be written on the front of the card, on or around the image, if one existed. The early 1900s are considered the golden age of the postcard.

The earliest postcards depicting Bennington are actual black-and-white photographs, printed on thick postcard stock with printed space for the address, message, and stamp on the back. Real-photo postcards were produced by professional photographers and amateurs alike. Kodak made it particularly easy for amateurs by producing a camera that took postcard-size images. Some models even had a window that allowed the photographer to write a caption on the negative itself prior to developing.

Early photographers still used large cameras and cumbersome glass-plate negatives. Frederick D. Burt was one of the more prolific photographers in the area, although he was only active in Bennington from around 1907 through 1912. Most of the real-photo postcards in this book were taken by Burt (his glass-plate negatives are now housed in the Bennington Museum). Burt worked with local shopkeeper Ernest T. Griswold to produce and market postcards of local attractions and events.

E.T. Griswold took over the family dry goods store on East Main Street in 1899, after his father passed away. He expanded the family business, changing it from a shop that sold only sporting and musical goods to one that sold almost anything, including art, stationery, picture frames, dynamite, masquerade materials, and postcards. He advertised his store as the "Most Interesting Shop in Town," and he certainly provided a most interesting variety of postcards.

In the 1920s, Griswold began to offer hand-colored cards. The cards themselves were mass printed, and then delicate watercolors were added by hand. Griswold was a member of the Sons of the American Revolution, and his interest in Bennington's history is shown in series of postcards he produced that illustrate the town's historic sites. He also produced a series titled Bennington Beautiful, which showcases the natural and cultural attractions of the area. Some, such as the new Allen-A factory, might not be what we would consider beautiful about the town today, but in the early 1900s, factories represented modernity and progress that were critical to the town's survival and prosperity. After Griswold's death in 1931, his postcards continued to be reprinted and new scenes were added.

There was also competition from companies in Germany, where there was a long tradition of lithography. The variety of German-made cards fell after World War I, but the quantity remained. Cards from the mid-1900s often feature simplified pictures and brilliant colors.

Most of the mill buildings in Bennington have been destroyed or repurposed, but tourism remains a driving industry for all of Vermont. Postcards are still produced in mass quantities for tourists and locals. Scenes of Bennington travel around the world with notes of "Wish you were here!"

One

STREETSCAPES, TOWNSCAPES, AND LANDSCAPES

Nestled between the Taconic and Green Mountain ranges, the Bennington area offers stunning panoramas in every direction. Mount Anthony in the Taconic range looms over the town to the west, and to the east the long ridge of the tree-covered Green Mountains begins its long stretch northward. Waterfalls abound through the region both natural and man-made, harkening back to Bennington's long history of mill industries. Farmland and pastures provide a bucolic backdrop.

The appearance of Bennington has undergone many changes throughout the years. When most of these postcards were published, the streets were still unpaved and trolley tracks ran down the middle of Main Street. Most of the countryside around town was cleared for agriculture. Much of the land has now been developed, but other former fields were neglected over the years until reclaimed by nature.

The original settlers of Bennington chose a hilltop for the town center. Although easily defensible and offering good views in every direction, it was far from sources of waterpower. Industry in Bennington grew up along the Walloomsac River, in what is now downtown, and in North Bennington along Paran Creek. There was a certain amount of rivalry and animosity between the old settlers on the hill, mostly still dependent on agriculture, and the industrial community along the river.

Much of the charm and history of Bennington remains today. Monument Avenue remains an iconic historic streetscape and Main Street retains its small-town charm.

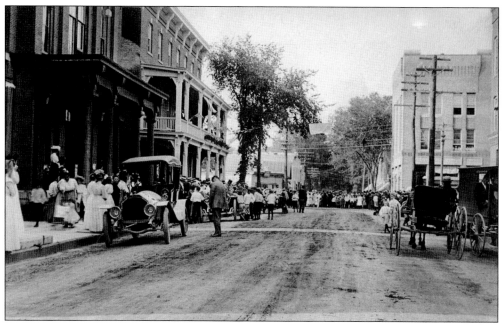

Both automobiles and horse-drawn carriages were in use around 1910, when Frederick Burt took this photograph of a crowd gathered at the Four Corners. The Bennington County Courthouse and the Putnam Hotel are on the left, and the Bennington County Savings Bank is on the far right. (Photograph by Frederick D. Burt.)

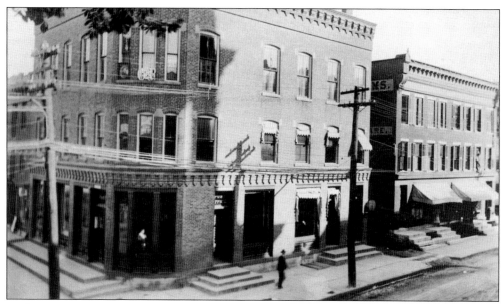

Built in 1886, the commercial building on the southeast corner of East Main and South Streets originally housed the post office and a jewelry store. It was later converted into a bank. The Cullinan Block was the three-story brick building behind it, which fronted on South Street and was demolished in March 1960.

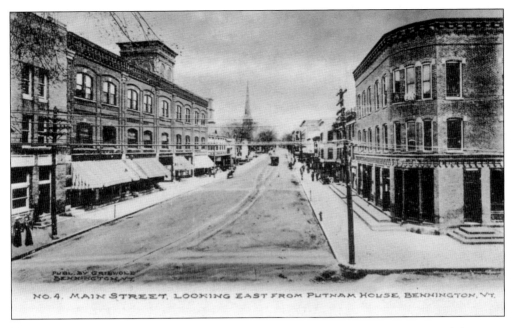

NO. 4. MAIN STREET, LOOKING EAST FROM PUTNAM HOUSE, BENNINGTON, VT.

Dramatic changes occurred on East Main Street between the early 1900s (above) and the 1970s (below). In the early 1900s, the north side of the street was dominated by the Bennington Opera House, which burned in 1959. Trolley tracks ran down the middle of the road, which was still unpaved. The Second Congregational Church, whose steeple is in the distance, was razed in 1959. Without the opera house, the Methodist church tower is visible in the 1970s on the left behind Bird's Photo Store and the Bennington Bookshop. The clock on the right was installed in 1928 to commemorate the 50th anniversary of the Bennington County National Bank. (Both, courtesy of Beverley Petrelis.)

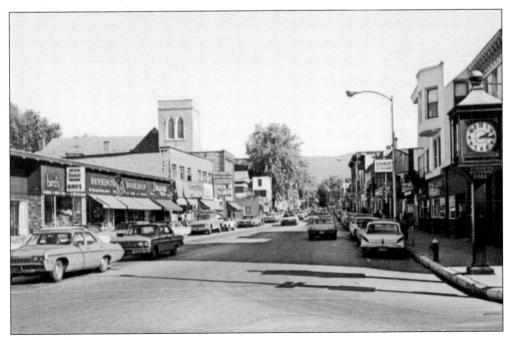

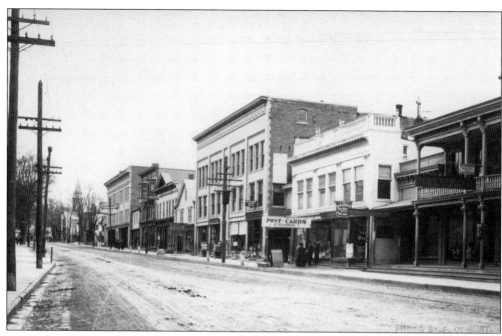

E.T. Griswold's store is directly under the sign advertising "Post Cards" on the south side of East Main Street near the four corners. Griswold claimed to own the "most interesting shop in town" and sold everything from dynamite to stationery. The sign for the *Bennington Banner* office is next door, and Gokay's drugstore is in the foreground. (Photograph by Frederick D. Burt.)

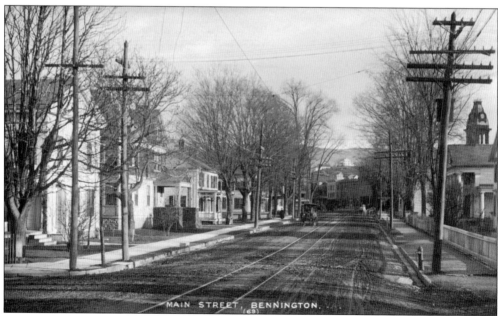

In a view looking east down West Main Street from the junction of Depot Street and Washington Avenue, the tower of the courthouse on South Street is visible on the far right. All the houses along this section of the street are gone except for one, replaced by gas stations, parking lots, and the Community College of Vermont. (Photograph by Banforth's Real Photos.)

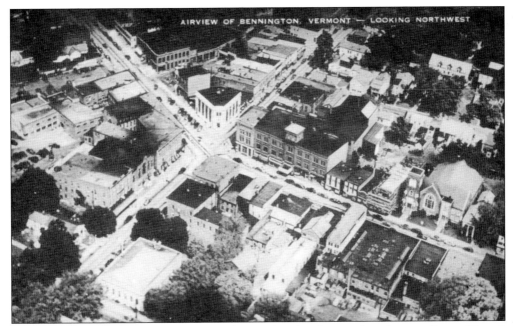

In the late 1940s, the General Stark Theater (in the former Bennington Opera House) dominated downtown. The Methodist church is to the right, and the First National Bank is on the corner across North Street. Southwest of the intersection are the Putnam House, the A&P Supermarket, and Drysdale's Store. The angled parking along the north side of West Main Street was eliminated in the mid-1900s. (Courtesy of Beverley Petrelis.)

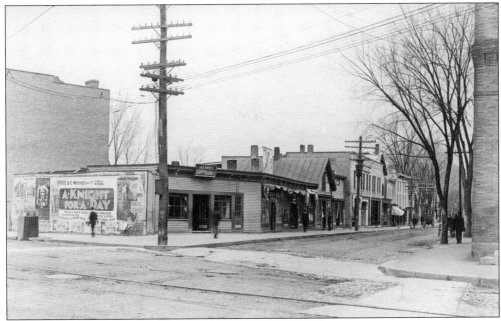

A.C. Sweet's Corner Market occupied the corner of North Street and West Main Street in 1910. The poster on the side of the building advertises a play at the Bennington Opera House, just across North Street. Although the streets were unpaved, there were paved crosswalks for the convenience of pedestrians. (Photograph by Frederick D. Burt.)

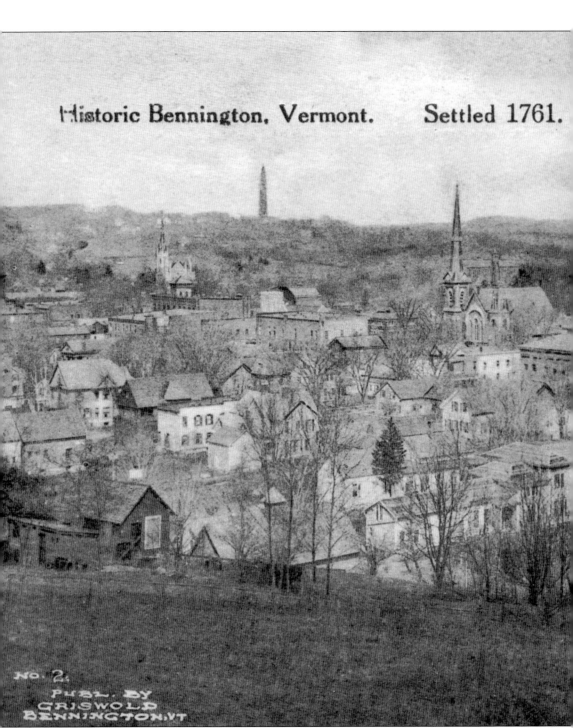

NO 2.
PUBL. BY
GRISWOLD
BENNINGTON.VT.

Walbridge Hill, now Imperial Avenue, offered a fabulous view of Bennington. The Bennington Battle Monument is in the far left distance, and the spire of the former Second Congregational Church is near the center of the picture. The Baptist church steeple is on the right. At the extreme left, the tower of the Bennington County Courthouse can be seen, and in between it and the monument is the spire of St. Francis de Sales Catholic Church. E.T. Griswold chose to

14

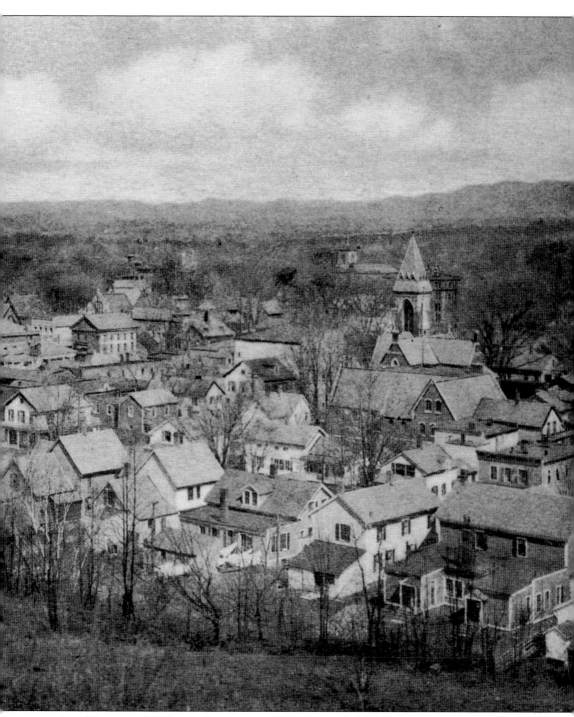

caption this postcard "Historic Bennington, Vermont, settled 1761"; however, this part of town was in fact not settled until much later. There was actually a certain degree of rivalry between the descendants of early settlers in Old Bennington on the hill and the upstart downtown industrial community.

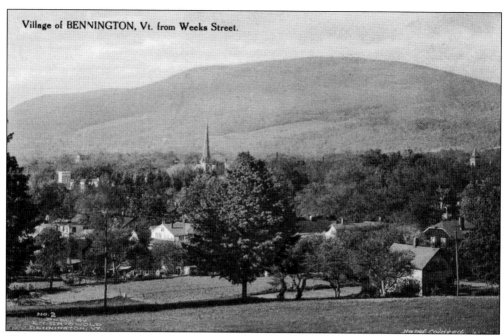

Village of BENNINGTON, Vt. from Weeks Street.

Three church towers rise above the trees in this view of Bennington taken from Weeks Street, just southwest of the Four Corners. The square tower of the Methodist church is on the left, the tall spire of Second Congregational Church rises in the center, and the Baptist church tower is on the far right. Bald Mountain is the wooded hill in the background. (Courtesy of Beverley Petrelis.)

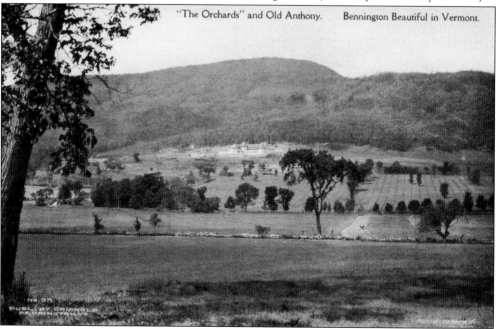

"The Orchards" and Old Anthony. Bennington Beautiful in Vermont.

When this postcard was mailed in 1918, the fields and countryside south of Bennington were not yet developed. Edward H. Everett's mansion is in the center, and a small portion of his 800-acre orchard is visible to the left. Everett's orchard was once the largest in the western hemisphere and included apple, pear, plum, and cherry trees.

In 1935, a new Bennington Free Library was built on the corner of Silver and Union Streets. The architect was Herbert T. Turner, the great-grandson of Trenor W. Park, who, along with Seth Hunt, had given the first public library building to the town in 1865. A later addition connected this structure with the original 1865 building on the corner of Main and Silver Streets. (Courtesy of Joe Hall.)

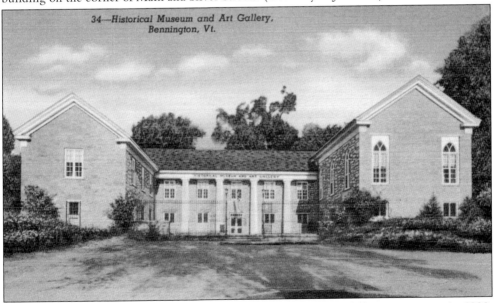

The Bennington Historical Society accomplished its goal of establishing a museum in 1928, seventy-six years after its incorporation. The wing on the right is the former St. Francis de Sales Catholic Church. Today, the museum houses over 30,000 historic and cultural artifacts, nearly 15,000 photographs, an extensive archive, and a research library related to Vermont and the surrounding region.

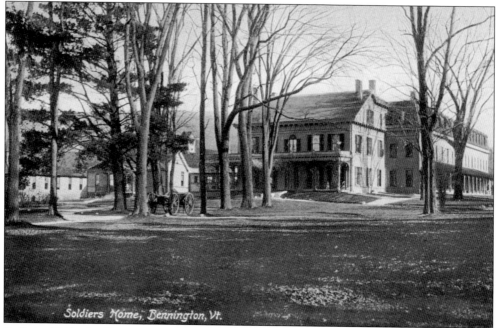

Soldiers Home, Bennington, Vt.

Built in 1860, the Vermont Veterans' Home was originally the summer mansion of Seth B. Hunt, a Bennington native and successful New York businessman. In 1886, it was converted into a home for sick and aging Civil War veterans. The large wing on the right was added the following year, and a hospital and chapel were built in 1891.

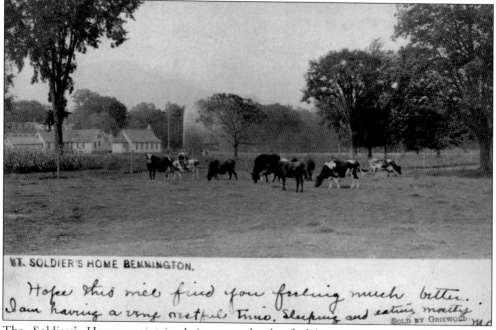

VT. SOLDIER'S HOME BENNINGTON.

Hope this will find you feeling much better. I am having a very restful time. Sleeping and eating mostly.

SOLD BY GRISWOLD

The Soldiers' Home maintained its own herd of dairy cows to provide milk for the residents. The message below the image reads, "Hope this will find you feeling much better. I am having a very restful time. Sleeping and eating mostly." The spray from the Hunt Fountain can be seen in the background.

The Hunt Fountain, on the front lawn of the Veterans' Home, was fed from a reservoir of pure springwater several miles away on Bald Mountain. When this postcard was printed, the fountain was the highest natural single-jet fountain in the world; water could reach 196 feet. The fountain was turned off in 1962 during a severe drought and was never turned on again.

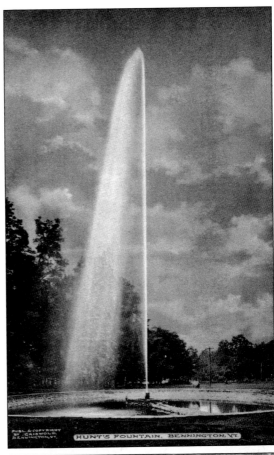

HUNT'S FOUNTAIN, BENNINGTON, VT

During his term as governor of Vermont from 1906 to 1908, Fletcher D. Proctor came to Bennington and enjoyed a driving tour of the Old Soldiers' Home. As governor, Proctor rejected fiscal conservatism and declared that the state had "a higher duty than to live cheaply." He applied managerial systems to state institutions, such as the Soldiers' Home.

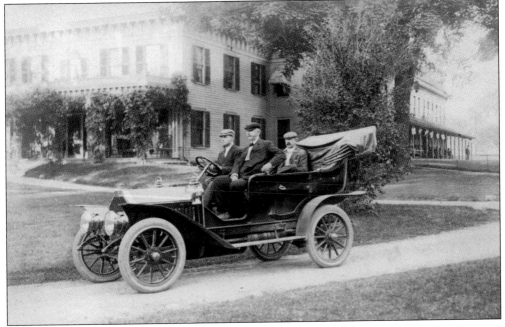

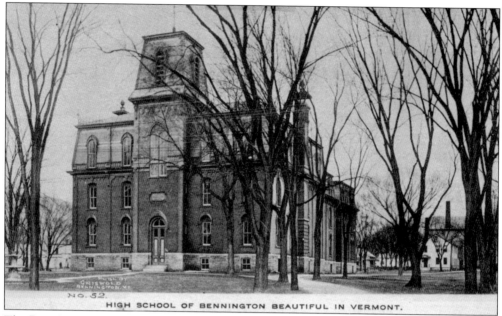

HIGH SCHOOL OF BENNINGTON BEAUTIFUL IN VERMONT.

The Bennington Graded School was established in 1874. The lower floors housed grades one through eight, and the top floor housed the high school. A teacher training program was added the following year. School directors felt external aesthetics were an important part of education, and the grounds were beautifully landscaped with a fountain in front and a house for the caretaker. The fountain was moved downtown in 2010.

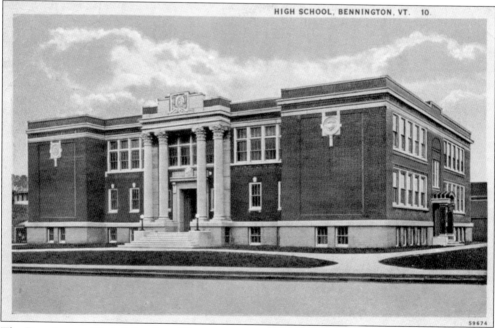

HIGH SCHOOL, BENNINGTON, VT. 10.

The Bennington High School, or "Benn Hi," as it was known, was erected in 1914. It had two entrances on the sides, one for boys and one for girls. The building served as the town's high school until 1966, when it became the junior high school. In 2004, the building became vacant. (Courtesy of Joe Hall.)

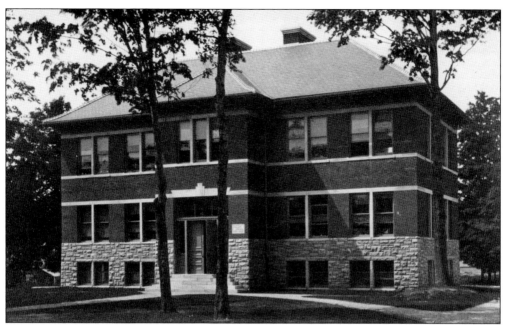

Kindergarten through third grade were taught at the Seventh Ward School, built in 1897 and named after Cora B. Whitney, a beloved teacher and principal. In 1998, the vacant building was transformed into a senior living facility, an excellent example of adaptive reuse of a historic property. (Photograph by Wills T. White.)

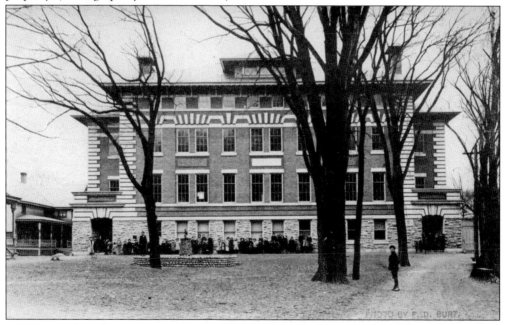

St. Francis de Sales Academy was built in 1899 for mostly Irish Catholic parishioners. Originally, the third story only contained one classroom, and the rest of the floor housed the local temperance society, the Ancient Order of Hibernians, and the Knights of Columbus, as well as an assembly hall. The building later became the Catamount Elementary School and was in use until 2007. (Photograph by Frederick D. Burt.)

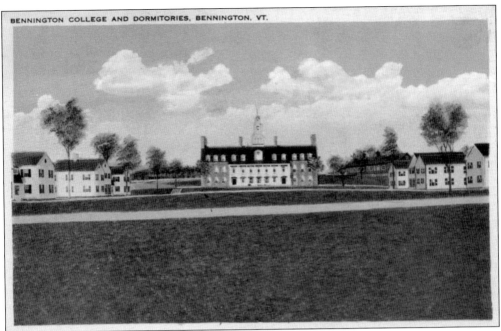

Bennington College opened in 1932 as a liberal arts college for women. Its educational plan was based on the philosophy of John Dewey. Students were exposed to traditional courses in the humanities and the sciences, but the visual and performing arts were of equal importance. All students were required to take a nine-week term off campus to gain experience in the real world.

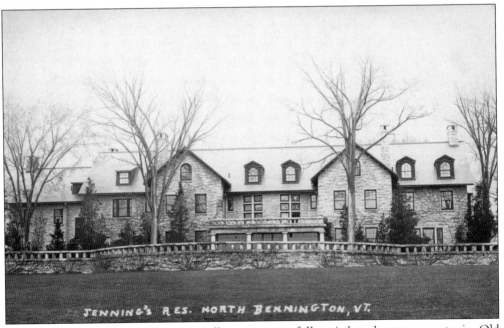

JENNING'S RES. NORTH BENNINGTON, VT.

After the founders of Bennington College unsuccessfully tried to locate property in Old Bennington, Laura Park Jennings donated her house and 140 acres to the school. The large mansion is known today as the Jennings Music Building.

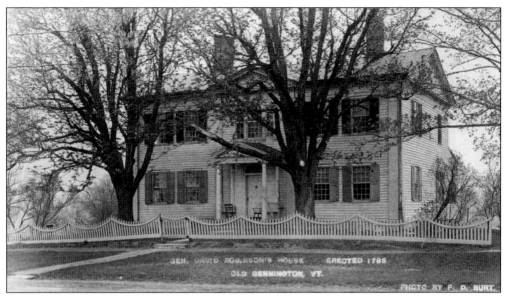

Gen. David Robinson built his imposing house on Monument Avenue in 1795. The Robinsons were among the first settlers in Bennington, and David distinguished himself at the Battle of Bennington. The house is an outstanding example of Georgian/Federal architecture and features a beautiful Palladian window. (Photograph by Frederick D. Burt, courtesy of Joe Hall.)

Although built in the early 20th century, this Colonial Revival house next to the Old First Church fits in beautifully with surrounding homes from the 1700s. For many years, it was the home of Fannie Abbott Meagher; more recently it was the residence of novelist John Gardner.

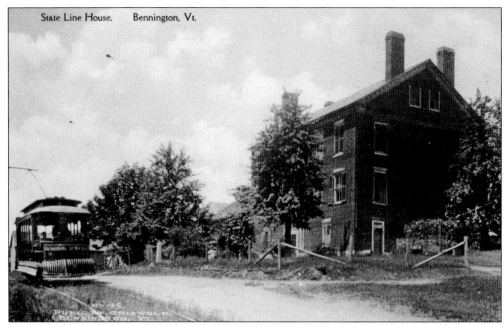

The State Line House was built by Col. David Matthews around 1800–1805 on the border between Vermont and New York. The west part of the house is in Hoosick, New York, and the east part is in Shaftsbury, Vermont. In the mid-1900s, it was a popular drinking hole for college students from Vermont and Massachusetts because the bar was in New York State, where the drinking age was 18.

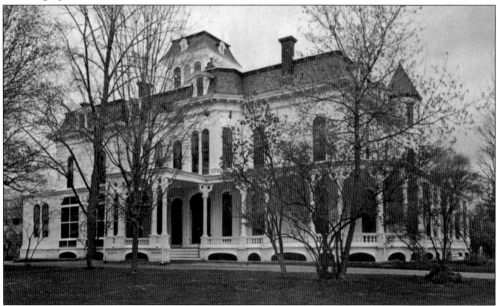

In 1865, after making a fortune in California during the Gold Rush, Trenor W. Park returned to his home state and built a magnificent mansion in North Bennington. Through the years, the house was occupied by Park, then his daughter, Eliza, and her husband, Gov. John G. McCullough, and then their daughter, Bess McCullough Turner Johnson. It is now maintained as a museum. (Courtesy of Joe Hall.)

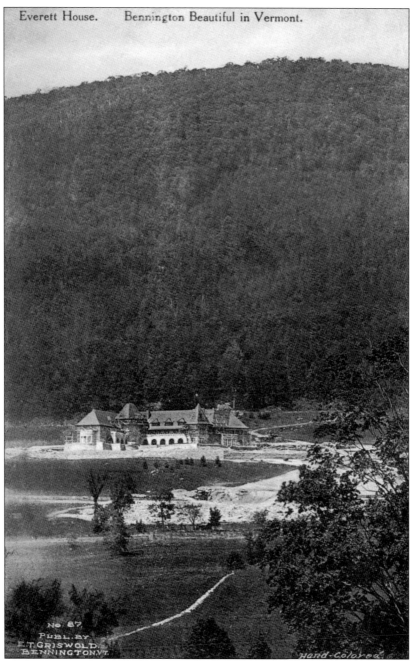

The summer residence of Edward H. Everett on the side of Mount Anthony was constructed in 1911–1912. Everett, who earned his fortune though glass, oil, and real estate investments, had family ties to Bennington. In addition to this mansion, Everett had houses in Washington, DC (now the Turkish Embassy), and Europe. He was an excellent horseman and enjoyed riding around his estate. To ensure high-quality work, he hired craftsmen from Italy to do the masonry, some of whom stayed in the area after the building was completed. After Everett's death, the estate was owned by the Order of the Holy Cross and is now the home of Southern Vermont College.

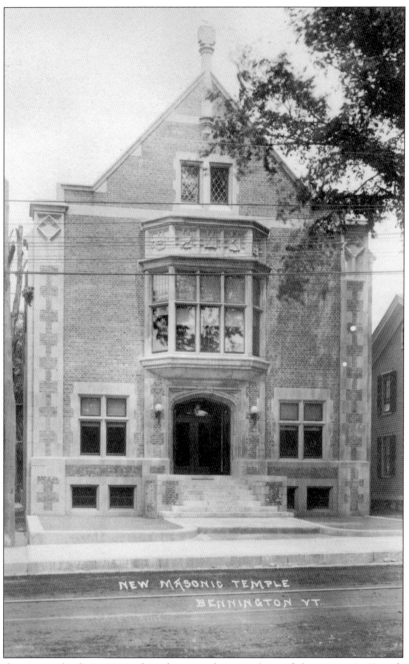

NEW MASONIC TEMPLE
BENNINGTON VT.

Shortly after it was built in 1911, this photograph was taken of the Masonic Temple, Mount Anthony Lodge No. 13, located at 504 East Main Street. The first Masonic lodge in town was chartered in 1824, but they met in rented quarters and it was not until this building was completed that they had a building of their own. The Tudor Revival brick building was designed by architects Harding and Seaver of Pittsfield, Massachusetts, and built on land donated by John Norton, the owner of the nearby pottery. Col. Olin Scott, who owned the Bennington Machine Works, paid for the construction of the building itself. Trolley tracks are clearly visible in the center of Main Street in front of the building. (Photograph by Frederick D. Burt.)

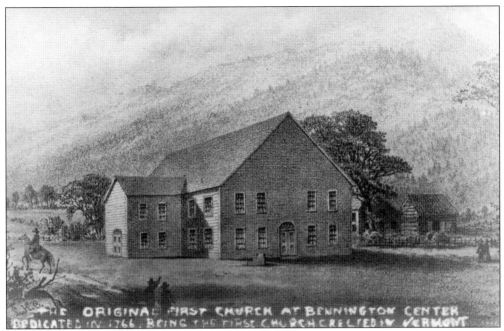

Bennington's first meetinghouse was dedicated in 1766 and was the first church in Vermont. In addition to religious gatherings, it was also used for public meetings and as a school. After the Battle of Bennington, British and German prisoners were held here. The building was razed after the new church was completed in 1806.

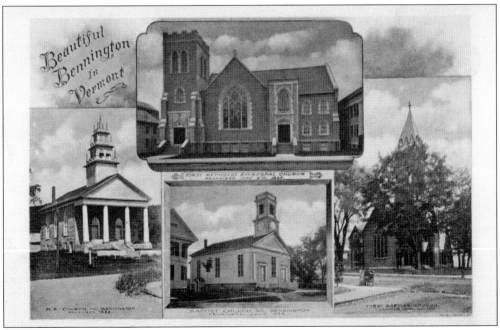

Featured clockwise from the top are the Methodist Episcopal Church, the First Baptist Church, the North Bennington Baptist Church, and the North Bennington Episcopal Church, which was located in the North Bennington neighborhood of Hinsdillville. (Courtesy of Joe Hall.)

45

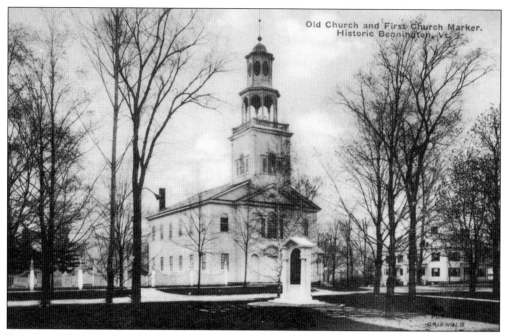

Bennington's Old First Church was built by Lavius Fillmore in 1806. The cost of the building was $7,793.20, raised almost completely from the sale of the first-floor pews. The grand style reflected the town's aspirations for the community. The monument on the village green in front of the church marks the site of the original meetinghouse.

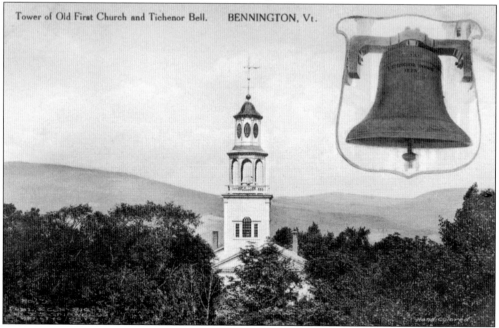

Vermont's fourth governor, Isaac Tichenor, personally donated a bell to the Old First Church in 1820. The unusual double-comet weathervane above the bell tower was probably modeled after Biela's Comet, first spotted in 1845 and again in 1852. The weathervane was installed during repairs to the church in the 1850s. (Courtesy of Beverley Petrelis.)

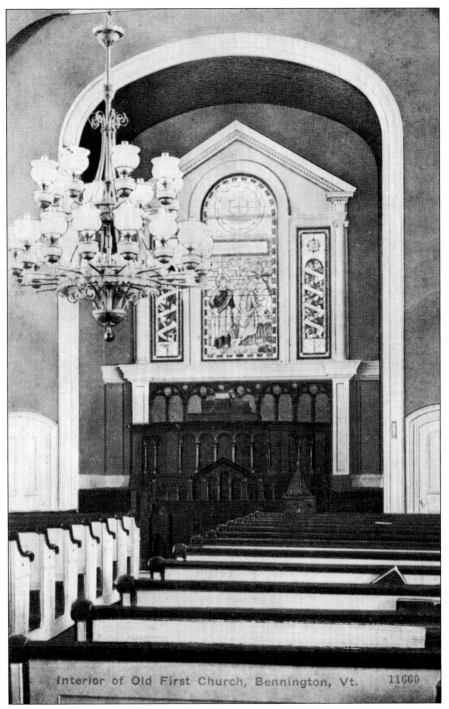

Interior of Old First Church, Bennington, Vt. 11660

During the mid-19th century, the Old First Church interior was remodeled in the Victorian fashion. A stained-glass window replaced the clear panes of the original building. Box pews were replaced with more conventional church pews, and the high pulpit was removed and completely redesigned to the tastes of the day. A large Victorian gas chandelier was also added. In 1937, the church was completely restored to the simple elegance of its original 1806 decor.

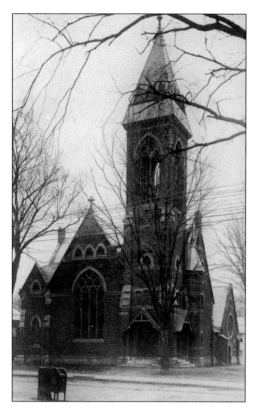

The First Baptist Church on the corner of Main and Valentine Streets was built in 1878. The congregation formed in 1827 and built their first meetinghouse in 1830, but it was destroyed by fire in 1845. In 1847, they built a new structure, which was replaced 30 years later by the current one. Over the years, many churches in Bennington have been forced to remove their high steeples, but this church is the only one in town to still have its tall bell tower. The interior of the First Baptist Church (below) shows the giant pipes of the organ on a balcony above the pulpit.

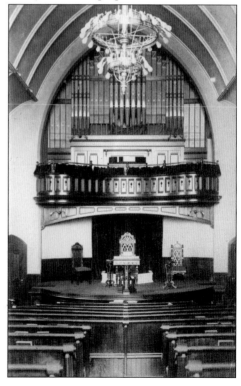

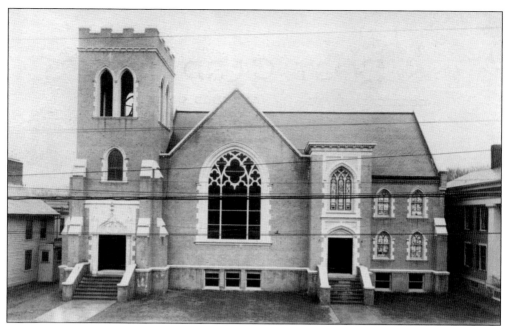

The Methodist Episcopal church in Bennington was organized in 1827. The 1833 fieldstone section is behind this 1909 Gothic Revival facade, which faces Main Street. The stained-glass windows were donated by William H. Bradford, who owned a large woolen mill, and William Morgan, a prominent landowner. In 2007, the building became the Green Mountain Christian Center.

By the 1830s, the population of Bennington had noticeably shifted down the hill towards the water-powered mills. In 1836, the Old First Church granted letters of Dismission to 45 of its members, allowing them to form a Second Congregational Church in the valley. A large Gothic-style building was dedicated in 1874. In 1959, the land was sold and cleared when a new church was constructed on Hillside Street.

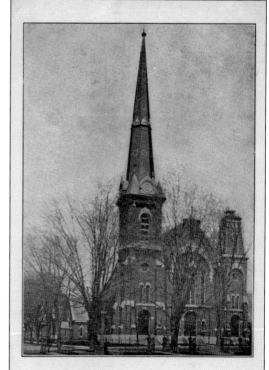

"Let us consider one another to provoke unto love and good works; not forsaking our own assembling together."—Heb. 10: 24, 25.

'The Master is here, and calleth thee."—John 11: 28.

"Whatsoever he saith unto you, do it."—John 2: 5.

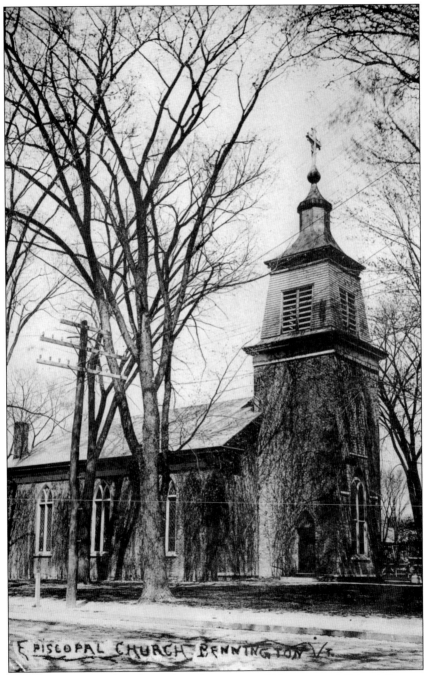

EPISCOPAL CHURCH BENNINGTON Vt.

St. Peter's Episcopal Church is located at the corner of Pleasant and School Streets. It was organized in 1834 under Rev. Nathaniel Preston; the building pictured here was erected two years later. The church was originally a brick structure and underwent extensive remodeling in 1859. In the intervening years, the church expanded to include a rectory and a parish house on the same lot facing Pleasant Street. The congregation met in this building until 1907, when it was torn down to make way for the present Gothic Revival structure. (Courtesy of Beverley Petrelis.)

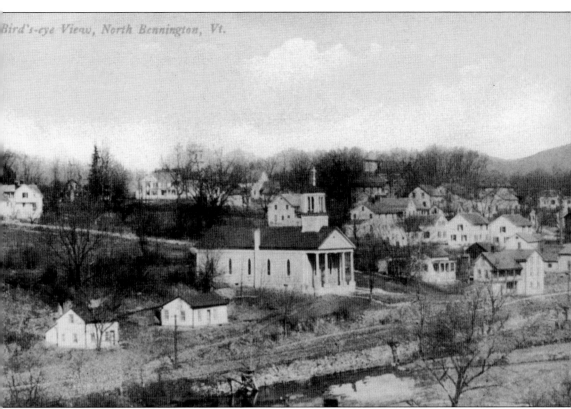

Bird's-eye View, North Bennington, Vt.

The Roman Catholic church in North Bennington was dedicated to St. John the Baptist in 1872. It was located on Water Street and was originally built as a Universalist Church in 1836. The Universalists used it until 1849, at which time it was fitted up as an academy. The building continued in that capacity until 1870, when North Bennington built a graded school, making the academy obsolete. The building was a Catholic church until 1929, at which time the church moved to their new building, designed by Boston architect John P. Heffernan, on Houghton Street. This building was subsequently razed. Until they had their own church, Catholics from North Bennington attended mass in either the Bennington church or the one in Rutland. (Courtesy of Joe Hall.)

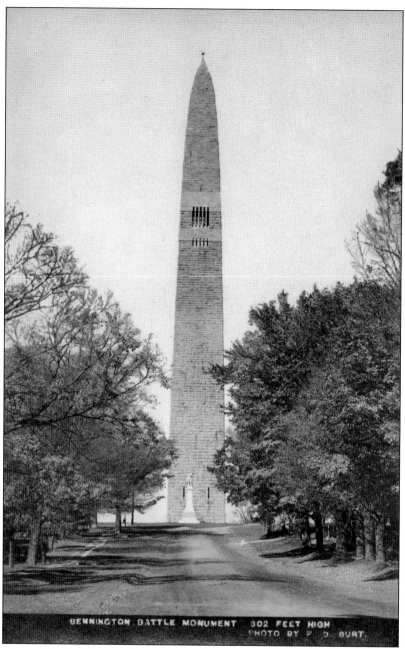

BENNINGTON BATTLE MONUMENT 302 FEET HIGH
PHOTO BY F. D. BURT.

The Bennington Battle Monument was erected to commemorate the Battle of Bennington, which took place on August 16, 1777, during the Revolutionary War, and helped tip the balance in favor of the Americans. The monument is the tallest man-made structure in Vermont and is 306 feet, 4.5 inches tall (including the star at the top). In 1877, Pres. Rutherford B. Hayes took part at the battle's centennial celebration, at which time it was decided that a monument of some type should be built. In 1891 (the 100th anniversary of Vermont statehood), the dedication ceremonies took place with Pres. Benjamin Harrison in attendance. A total of 412 steps (or a quick elevator ride) brings visitors to the observation deck near the top of the monument for a panoramic view of the surrounding countryside. (Photograph by Frederick D. Burt.)

Three

MONUMENTS
AND MARKERS

Benningtonians, conscious of their town's historic significance, erected many monuments and markers in the late 1800s and early 1900s. They had many things to be proud of. Bennington was the first incorporated English-speaking town established in Vermont. The town was central in the conflict between the New Hampshire Grants and "Yorkers." The famous abolitionist William Lloyd Garrison began his career editing a local newspaper.

Most significantly, during the Revolutionary War, a storehouse here was the object of the Battle of Bennington, and the town was the planning and staging area for the Americans. A stone now marks the approximate site of the continental storehouse, and a large obelisk commemorates the battle. The Bennington Battle Monument, the tallest man-made structure in the state, was dedicated in 1891 and is a source of great pride, not only to the people of Bennington, but to all Vermonters and, indeed, to patriots everywhere. Statues of heroes such as Seth Warner and John Stark were later installed on the grounds. Nearby locations related to the battle were also commemorated, such as the camping ground where John Stark stayed the night before, the location of the tavern where patriots met to plan the attack, and, of course, the burial places of men who died.

Monuments and memorials helped to promote the area as a tourist destination with historical significance.

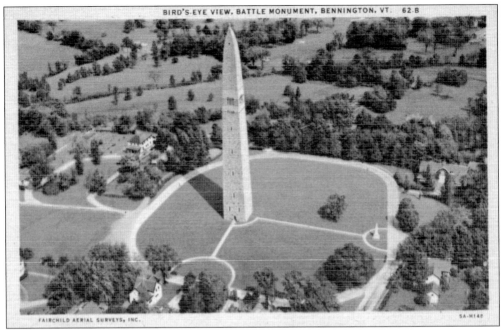

FAIRCHILD AERIAL SURVEYS, INC. 5A-H148

Several historic buildings were demolished and the road was completely rerouted to create the manicured grounds of the battle monument. At the right is the statue of Seth Warner; the visitor center is partially hidden by trees at bottom of the picture.

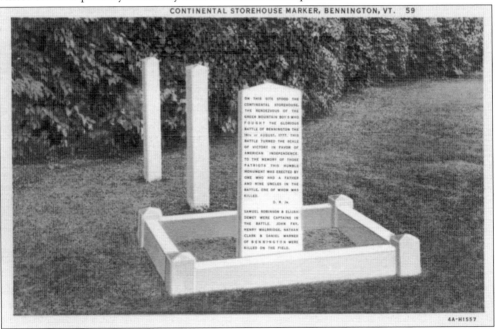

4A-H1557

General Burgoyne knew that there was a continental storehouse in Bennington near where the monument is today. He was short on provisions and sent Col. Friedrich Baum and his Hessians to capture it and bring back supplies. Burgoyne had been told incorrectly that Bennington was loyal to the crown and would help him with the supplies he needed. A stone now marks the approximate site of that storehouse.

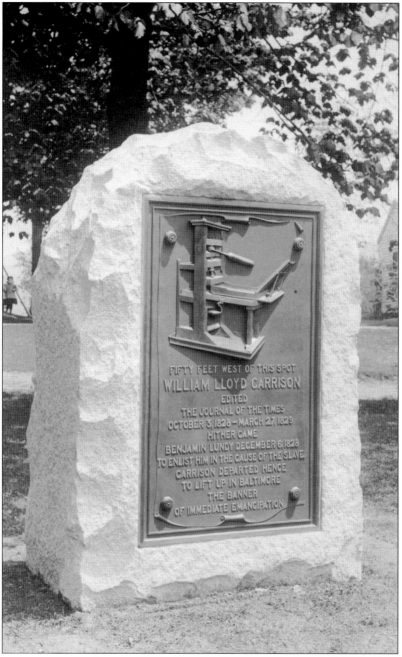

FIFTY FEET WEST OF THIS SPOT
WILLIAM LLOYD GARRISON
EDITED
THE JOURNAL OF THE TIMES
OCTOBER 3, 1828 – MARCH 27, 1829
HITHER CAME
BENJAMIN LUNDY DECEMBER 6, 1828
TO ENLIST HIM IN THE CAUSE OF THE SLAVE
GARRISON DEPARTED HENCE
TO LIFT UP IN BALTIMORE
THE BANNER
OF IMMEDIATE EMANCIPATION

The William Lloyd Garrison Memorial on the Old Bennington Village Green commemorates Garrison's one-year stay in Bennington from 1828 until 1829. At that time, he worked as the editor of the *Journal of the Times,* a newspaper that was printed nearby. Garrison became a central figure in the early abolitionist movement in America, in which Vermont was actively involved. After working in Bennington, Garrison left for Baltimore, where he founded the *Liberator,* a newspaper that became the most influential abolitionist publication in America in the years before the Civil War. The monument was erected with donations from local townspeople, as well as wealthy summer visitors, including Andrew Carnegie.

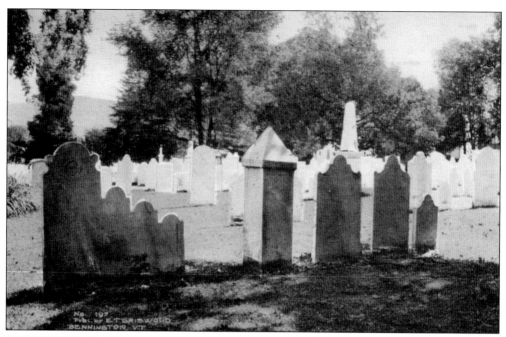

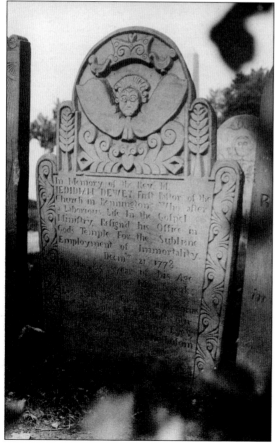

Marble for the earliest stones in the Old First Church cemetery was quarried nearby in Shaftsbury. Many stones can be attributed to the famous gravestone carver Zerubbabel Collins, known for his distinct style that includes ornate flowers and cherubic winged soul effigies. Established in 1762, this cemetery is the earliest burying ground in Vermont. Five Vermont governors and most of Bennington's founding fathers are interred here.

Rev. Jedidiah Dewey became the first pastor of Bennington's Congregational Church in 1763. The winged head on his gravestone symbolizes the transition of the deceased's soul from earthly to heavenly realms, and the inscription describes the minister's transition to "the Sublime Employment of Immortality." After years of wear and several accidents, the original stone was transferred to the Bennington Museum and a replica installed in its place.

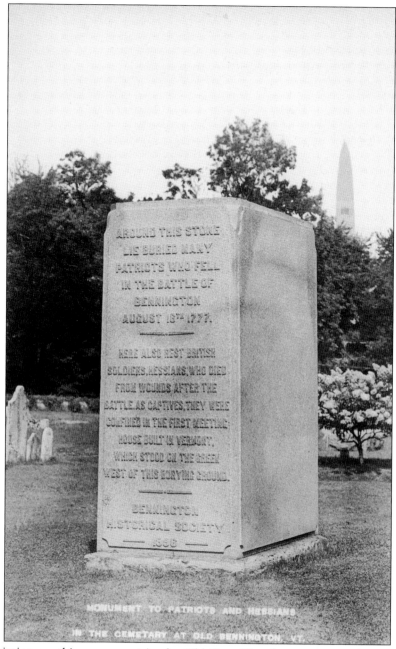

The inscription on this monument in the Old First Church cemetery reads, "Around this stone lie buried many patriots who fell in the Battle of Bennington August 16th 1777. Here also rest British soldiers, Hessians, who died from wounds after the battle. As captives they were confined in the first meeting house built in Vermont, which stood on the green west of this burying ground." More recently, the actual names of the deceased have been added to the stone, and the bones of David Redding were interred nearby. Redding had been hanged as a Loyalist traitor in 1778, but at the time the cemetery refused to bury him. His bones were used in the local school to teach anatomy, and later given to the Bennington Museum. In 1981, his remains were finally laid to rest. (Photograph by Frederick D. Burt.)

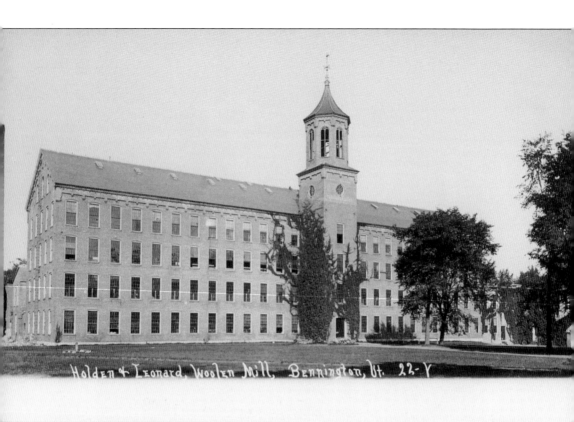

Holden + Leonard Woolen Mill, Bennington, Vt. 22-Y

The Holden-Leonard Mill, or the "Big Mill," as it is known locally, was built in 1865 by Seth B. Hunt to manufacture shawls. The first shawl produced at Hunt's factory was given to Celestia Keyes, daughter of Samuel Keyes, the contractor who put up the building. Upon completion of the smokestack, the 16-year-old Celestia had the courage to climb up the rungs inside the stack and wave a handkerchief from the top. Originally, Hunt manufactured plaid and paisley shawls here, but as fashions changed the mill was used for a wide variety of textiles. At one time, nearly 800 people were employed here. The factory closed in 1987. (Photograph by Emoor & Hayward.)

Four

BUSINESS AND INDUSTRY

Most of the original residents of Bennington were subsistence farmers, but as soon as the town could support them, mills were constructed and specialized tradesmen were encouraged to settle. Mills were built along area rivers and creeks (particularly the Walloomsac River in Bennington and Paran Creek in North Bennington) as early as the 1770s, grinding grains and sawing lumber for local consumption. The water was later harnessed to power factories, producing a wide variety of products, including textiles, furniture, paper, machinery, and pottery.

Early industries took advantage of the area's natural resources. Iron, ochre, and clay were all mined in the area and contributed to the local economy. As vast forests were cleared for pasture and fields, trees were converted to charcoal and potash as well as lumber. The logging industry was strong for many years, and local wood was used by manufacturers to make furniture for the national market.

Although farming decreased over time, it continued to play an important part in the local economy, and the agriculture industry is still active today. The dairy industry in particular was important from the beginning, and Vermont is still known for its ice cream and cheese. Although not significant today, wool was a driving force for industry in Vermont, and particularly in Bennington. Merino sheep (known for their high-quality wool) were first imported to Vermont in 1811, and by 1837 there were over one million sheep in the state. Bennington was particularly noted for the number of mills specializing in wool knit underwear (most mills in New England made woven cloth). An order of knitting machinery from Henry Bradford is part of what inspired Charles Cooper to move his machine works to Bennington, where he manufactured the machinery used in knitting mills as far away as England.

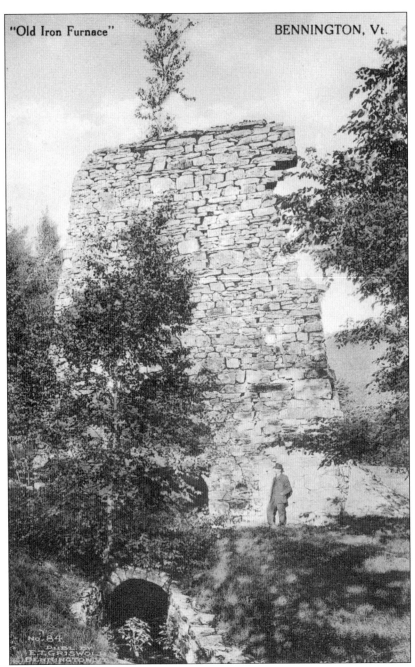

"Old Iron Furnace"　　　　　　　　　　　　　　BENNINGTON, Vt.

Several iron ore furnaces were located in Furnace Grove on the road to Woodford. The furnaces were built in the early 1800s and operated under the Bennington Iron Company until about 1848. They used local iron ore dug in nearby mines to make crude pig iron ingots that were sent to Troy for processing. Products like horseshoes, stoves, and heavy machinery were forged from the iron. The furnaces made use of Vermont's plentiful forests and converted wood into charcoal for use in the blast furnaces. Eventually, the natural resources were depleted and the industry faded away. The ruins of the furnaces were popular tourist spots 100 years ago, but they have now become overgrown.

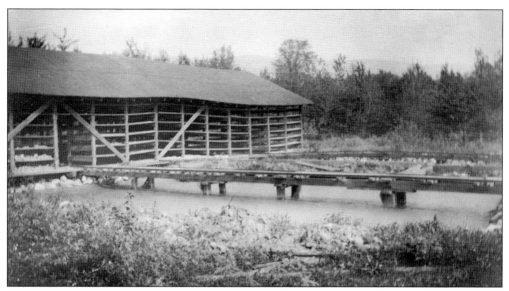

Several firms mined ochre along Bennington's Roaring Branch. Water from washing the ore sat in large vats (in the foreground) until the pigment settled out. The clay was then cut into bricks and put upon shelves to dry (in the background). The pigment was naturally yellow, but could be processed in a large oven to produce red paint. The flood of 1927 wiped out most of Bennington's ochre deposits. (Photograph by Frederick Cowan.)

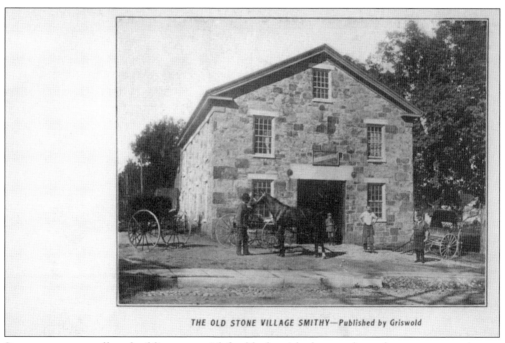

THE OLD STONE VILLAGE SMITHY—Published by Griswold

Stone was an excellent building material for blacksmith shops, where there was great danger of fire. The old stone blacksmith shop that still stands at the corner of South and Elm Streets was probably built in 1845 by Graves and Root, partners who ran a tinware business. Later, this building served many other purposes, including the police station, a girl's club, and a downtown visitors center.

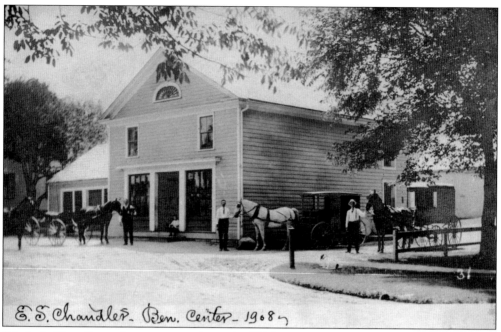

E. S. Chandler. Ben. Center - 1908

Edwin S. Chandler took over a general store in Old Bennington from his father in 1858 and ran it for 35 years. When this photograph was taken in 1908, it had been sold to William Miller, who had worked for Chandler. The building was moved twice, first just across Monument Avenue, and then down West Road, where it is now a private residence across from Camelot Village.

Carts delivered goods directly to customers from the Chandler Store in 1912. The man and horse are identified on the back as "Old Jack and Baldy" (it is not clear which is the man and which is the horse). Their cart is marked with the store's address in Old Bennington and its three-digit telephone number, 112.

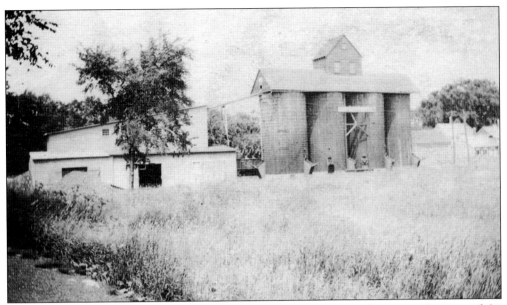

Tuttle's Coal Yard supplied the people of Bennington with fuel for heating at the turn of the century. Coal was stored in large silos and conveyor belts were used to load and unload trucks. The location is now the parking lot on Depot Street behind the Bennington Station Restaurant. (Photograph by Frederick Cowan.)

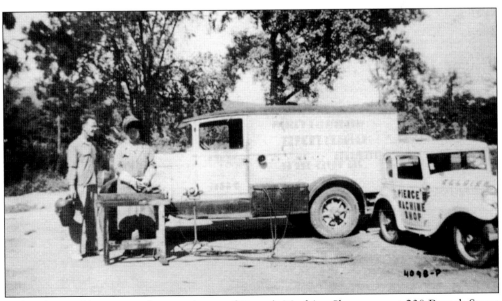

Joel and Lena Pierce were the proprietors of Pierce's Machine Shop, once at 230 Branch Street in Bennington. Unlike many women at the time, Lena worked alongside her husband in the shop, greasy hands and all. In this postcard, the couple poses with some of their machinery and their truck. Joel is holding a welding mask. (Courtesy of Joe Hall.)

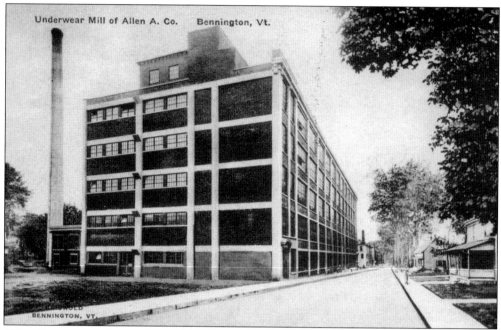

Allen-A was one of several companies in Bennington that manufactured knit underwear in the early 1900s. The caption on the back of this card boasts that its factory "has two-hundred thousand square feet of floor area, and is most modern in its equipment for the health and comfort of its 600 employees . . . [It makes] approximately 10,000 garments daily, or more than two and one half million garments annually." (Courtesy of Joe Hall.)

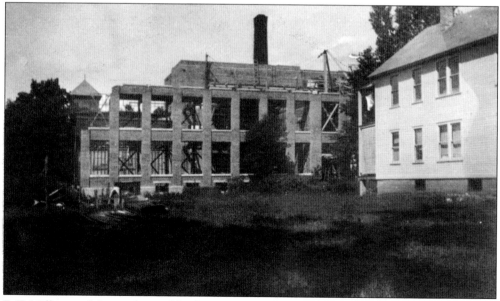

E-Z Mills was doing such good business in 1913 that it built a second larger factory (under construction in this photograph) on Gage Street in Bennington after a fire destroyed its North Bennington mill. The patented "E-Z Waist" underwear for children was sold nationally. The company remained in town until 1952, when it moved its operations to Georgia. (Photograph by Frederick Cowan.)

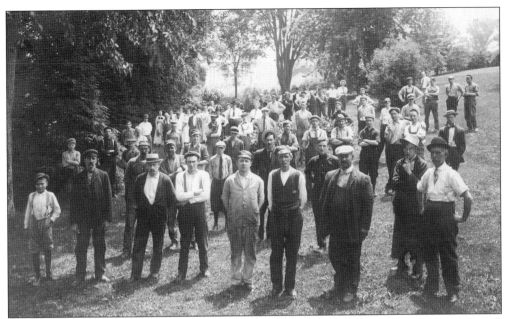

The event that prompted this photograph of the employees of the H.C. White factory in North Bennington is unknown. The company made stereoscopes and later became famous for its Kiddie Kar riding toy, invented in 1915 by Clarence White. The mustachioed man in the center with a straw hat is identified as Edmund J. Worthington, the superintendent at the factory.

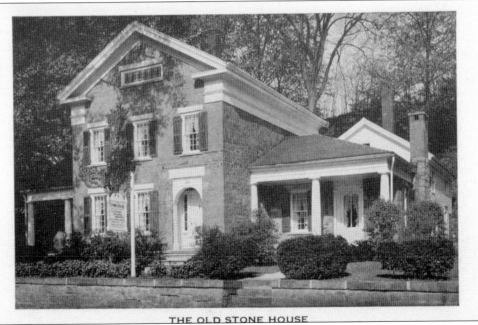

THE OLD STONE HOUSE

As the H.T. Cushman Company flourished in the mid-1900s, the Cushman family transformed their home across the road from the factory in North Bennington into a tourist destination advertising the company's Colonial Creations line of maple furniture. Caroline Wellington, daughter of the company's founder, was employed as the decorator for the showrooms. The building is still standing, but is now in a sad state of disrepair.

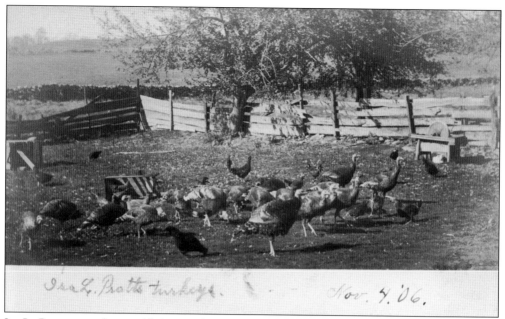

Isa L. Pratt was a housewife in North Bennington who had a side business raising turkeys. Note the whetstone for sharpening knives in the right background and the date—November 4, 1906. It seems likely that these birds are destined for the Thanksgiving table. (Photograph by Frederick D. Burt.)

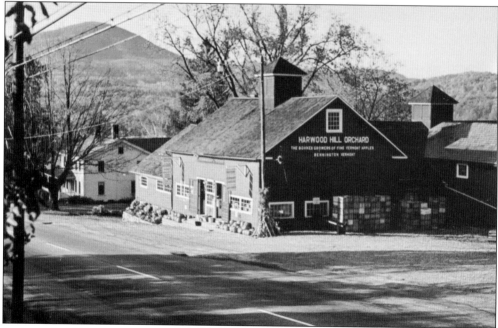

In the early 1800s, part of the Harwood family settled on the hill north of town that later bore their name. They operated a dairy farm, and later grew apples under the care of S. Everett Harwood. The orchard remained in the family until 1949. The property is now owned by Bennington Project Independence, an adult day care facility. (Courtesy of Joe Hall.)

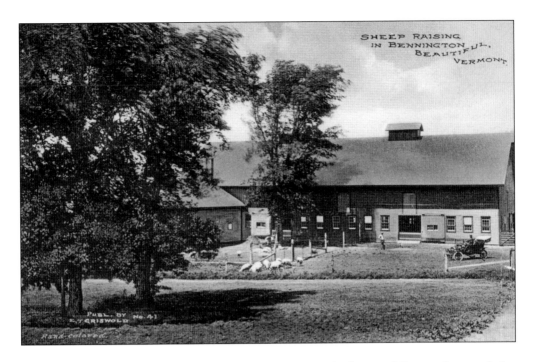

James C. Colgate built Fillmore Farm's prizewinning herd of Horned Dorset sheep and also started a dairy, which later became the employee-owned Fairdale Farms on West Road. The card above boasts, "Breeding stock is shipped from here all over the country, and the superiority of Vermont as a section for producing the highest class of rugged sires and dams is strongly demonstrated by the numbers of premiums taken by these farms." Workers used modern electric equipment to shear the flock of 700 sheep (below). (Below, photograph by Wills T. White.)

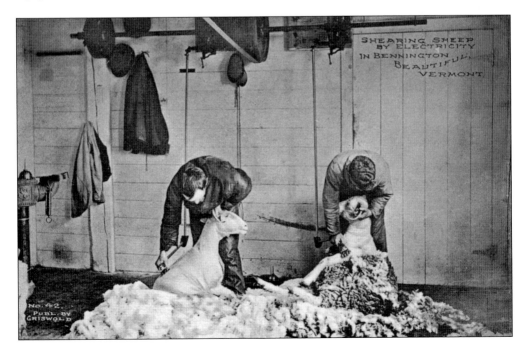

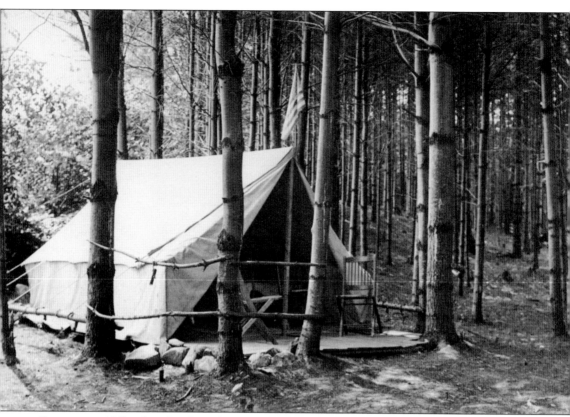

For many middle-class families, the outdoors was the ideal place to spend the summer. For those who did not have access to a cottage, a tent platform, folding furniture, and sturdy tent made the great outdoors more accessible than ever before. "Gypsying," or auto-camping, simply involved packing up gear in the back of the family car, driving somewhere scenic, and setting up camp. Campers might dine on fresh-caught fish or cans of soup warmed over a campfire. A tent platform, like the one in this photograph, added the bonus of a dry, flat surface. (Photograph by Frederick D. Burt.)

Five

THE GREAT OUTDOORS

The Bennington area offers visitors a wide variety of outdoor activities including hiking, swimming, fishing, hunting, skiing, skating, and snowshoeing. Around the turn of the century, Teddy Roosevelt introduced Americans to the joys and rigors of outdoor recreation. Summer camps, private or sponsored by social groups, appeared all over New England. For many middle- and upper-class families, camp was the ideal way for their children to spend the summer. Many New England families had their own rustic cottages built in the nearby mountains where they could escape the heat.

Benningtonians of all ages retreated to the hills in the hot summer months. With camps named Loafmore and Hunters' Rest, there is no doubt that these were places of relaxation and recreation. For those inclined to exertion, opportunities for hiking abounded. The Long Trail is the oldest long-distance hiking trail in the country, predating the Appalachian Trail, which shares part of its route, by 10 years. The trail runs along the Green Mountains the length of Vermont, from just south of Bennington up to the Canadian border. The Green Mountain National Forest protects much of the trail from development and offers the same outdoor recreation as it did 100 years ago. Responsibility for caring for the trail rests with the Green Mountain Club, which was founded in 1910 and is still a strong advocate for Vermont's nature lovers.

The woods are also home to bountiful wildlife, attracting hunters and fisherman. Development has changed the number and variety of wild animals in the area. As early as the 1800s, there were restrictions protecting species like the white-tailed deer, and hatcheries later ensured a healthy trout population. Other species like the catamount and the timber wolf were less lucky, but their extirpation from the area left room for small hunters like the bobcat.

For those preferring a more civilized outdoor experience, the Mount Anthony Country Club and the deer park offer outdoor activities of a less risky sort.

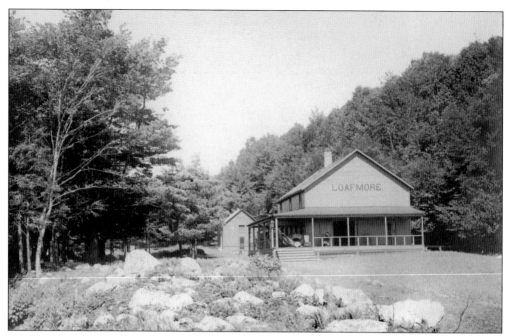

Loafmore was one of the many camps that dotted the hills around Bennington. It was opened in the 1890s in the Hell Hollow section of Woodford. Visitors enjoyed a hardwood dance floor, an outdoor dining area, and a large stone fireplace. The building burned down around the time of World War I.

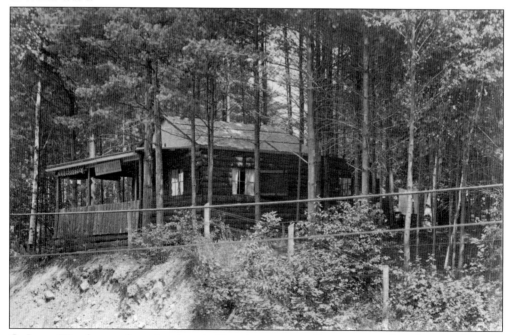

C. Lynn Wood owned a print shop in Bennington as well as a camp, cleverly named Camp Linwood, at Barber Pines on the Pownal Road. The trolley line to Williamstown ran right below the camp, giving easy access to the cabin; the power lines for the trolley run through the bottom of this photograph. (Photograph by Frederick D. Burt.)

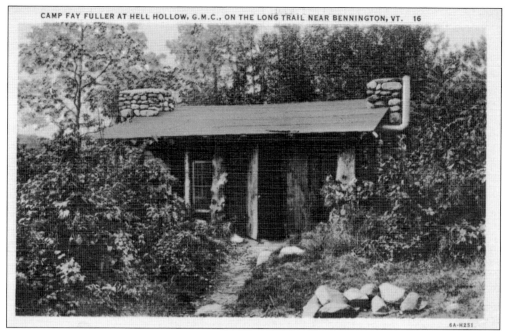

The Green Mountain Club was founded in 1910 to build Vermont's Long Trail, the oldest long-distance hiking trail in America. The club built camps along the trail to shelter weary hikers. Camp Fay Fuller in Woodford was dedicated in 1927 and named for the first woman known to hike to the top of Mount Rainier in Washington State. (Courtesy of Joe Hall.)

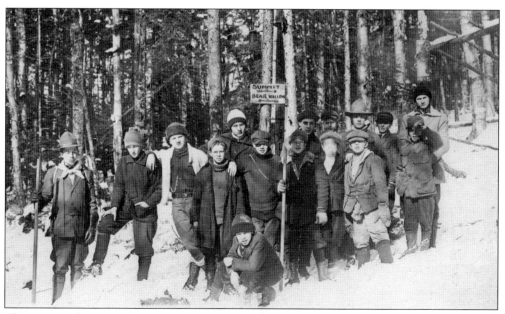

This group of young hikers standing in front of a signpost is presumably on the Long Trail, or perhaps near the summit of Bald Mountain. The sign points the way to Summit and Bear Wallow, which is located four miles from Bennington on Bald Mountain accessible from a trail winding up from Woodford Hollow.

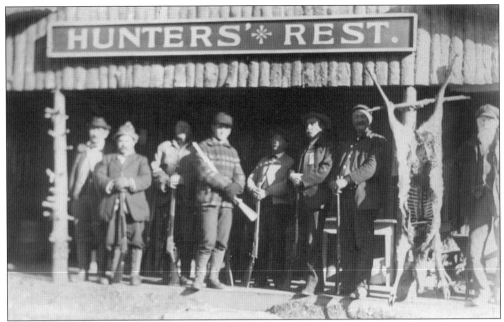

HUNTERS' ✻ REST.

Hunter's Rest was one of many hunting camps in Woodford that served as a base for Benningtonians hunting in the Green Mountains. At one point, overhunting and deforestation threatened the white-tailed deer population in Vermont, but by the early 1800s, regulations were in place to ensure the survival of the species.

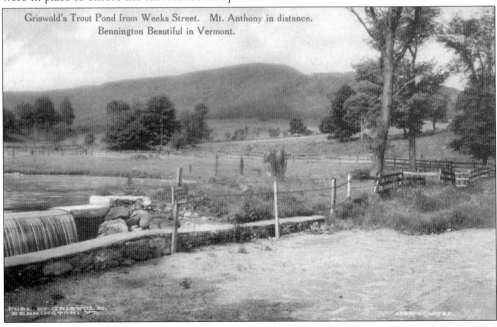

Griswold's Trout Pond from Weeks Street. Mt. Anthony in distance. Bennington Beautiful in Vermont.

There were several private trout ponds in Bennington, including one on the property of E.T. Griswold on Weeks Street. Trout were purchased from a hatchery (the second-oldest in the state) on South Stream Road. Griswold owned a store on Main Street that sold sporting goods and produced a series of postcards promoting Bennington's outdoor attractions. Many of his postcards appear in this book.

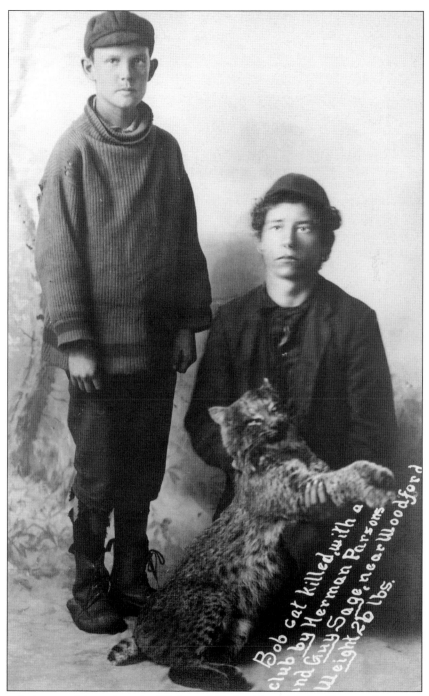

The inscription on this card reads, "Bob cat killed with a club by Herman Parsons and Guy Sage, near Woodford. Weight 26 pounds." Extirpation of the catamount and wolf in the 1800s left a predator void in the Green Mountains, which was filled in part by bobcats. The average bobcat is somewhat larger than a big house cat, averaging 15 to 20 pounds, although some larger males reach 40–45 pounds. Eastern bobcats are still relatively common in Vermont, although they are solitary animals and are rarely seen. (Photograph by Wills T. White.)

Visiting Martin Greene, the "Hermit of Sucker Pond," was promoted among Bennington's more eccentric tourist attractions in 1906. The story was that Greene decided to retreat to the wilderness due to an unfaithful woman. Sucker Pond, also known as Lake Hancock, was once Bennington's water supply. It is southeast of town, and although the pond is technically in Stamford, the water and surrounding banks belong to Bennington. In recent years, the trails around the pond have been restricted due to the abuse of ATV owners. (Below, photograph by Frederick D. Burt.)

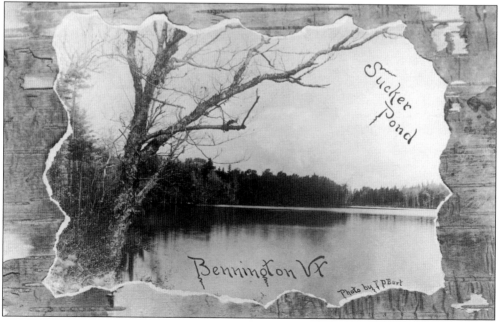

Sucker Pond

Bennington VT

Photo by F P Burt

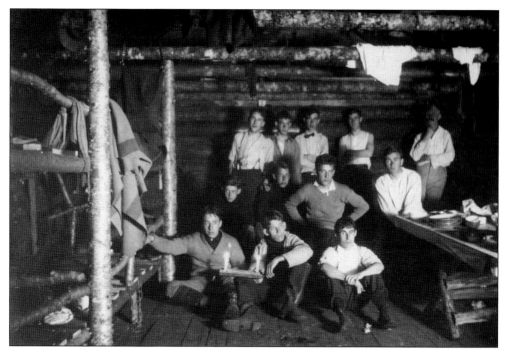

The Civilian Conservation Corps was established by Franklin D. Roosevelt in the 1930s. There were several CCC camps in Vermont. During the Great Depression, the federal government paid the workers salaries to build roads, mountain trails, and bridges in state parks. (Photograph by W. Holt.)

E.T. Griswold boasts in the caption of this postcard, "The mountain woods-roads about Bennington are generously patronized by the fleet-footed deer, sly fox and occasional bear. In winter, they afford attractive highways for snowshoeing." The woods around Bennington still offer beautiful spaces for winter recreation. (Photograph by W.S. Carpenter.)

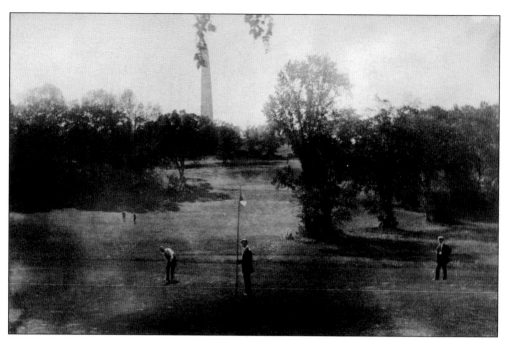

The Mount Anthony Country Club was established in 1897. The golf course (above) featured 18 holes and climbed the north side of the hill below Monument Avenue. In 1905, membership dues for the Country Club were $15 for men and $25 for women, with an additional $10 fee for use of the golf links. The original clubhouse (below) was once the home of the Clark family. The structure was destroyed by fire in the 1950s but quickly rebuilt. In the 1960s, the Bennington Rotary provided a rope tow on the ninth hole for skiers and sledders to enjoy in the winter.

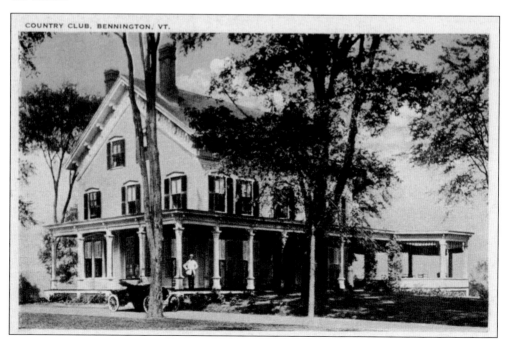

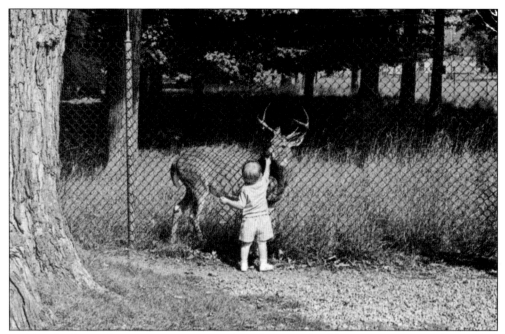

Visiting the deer at the Bennington Deer Park on the grounds of the Vermont Veterans' Home has been popular with the young and old for decades. Staff at the home takes care of the herd of about 10 white-tailed deer year-round. The large fenced-in area is located between the home itself and the state office buildings behind the chamber of commerce. (Courtesy of Beverley Petrelis.)

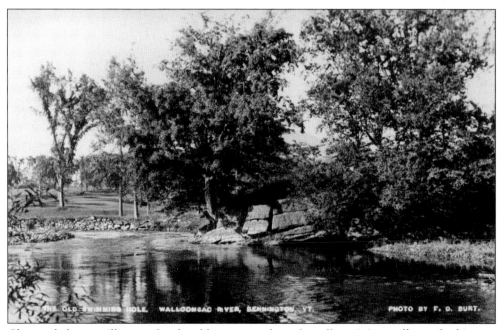

Clear and almost still water, bordered by some rocks and small retaining walls, made this spot on the Walloomsac River a popular place for a dip on a hot summer day. The old swimming hole was located at the base of the Mount Anthony Country Club golf course. (Photograph by Frederick D. Burt.)

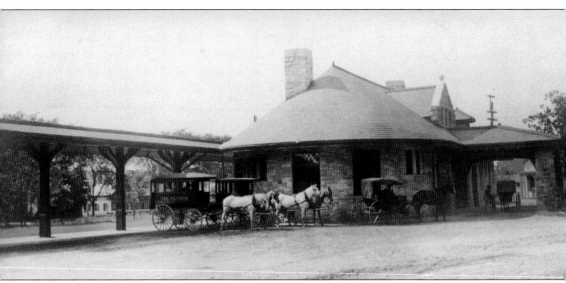

Railroad tracks first connected Bennington to the world in 1852. When wealthy North Bennington resident Trenor Park purchased the Bennington-Rutland Railroad, he found that the railroad barons of the Troy and Boston Railroad refused him access to their New York lines. After an unsuccessful "Railroad War," Park built a rail line from Bennington to Lebanon Springs, New York, where he could transfer his trains to southbound rails while bypassing Troy. Tight turns and hilly terrain gave this stretch of railroad the name Corkscrew. Bennington's stone depot replaced the original wooden station in 1898, following designs provided by architect William C. Bull. In 1932, passenger service to Bennington was discontinued. One of the carriages in this image is marked "The Putnam," for the Putnam House Hotel on Main Street, which would have sent a driver to pick up its guests.

Six

TRAVEL, TRANSPORTATION, AND TOURISTS

Bennington was established during the age of horse-drawn wagons and carriages. The mountainous region was not conducive to canals, and so until the development of railroads, industrial growth was limited. In 1852, the first train arrived, and railroads soon connected the area to towns and cities all over the country. The railroads opened Vermont's lumber, dairy, granite, marble, and slate industries to large eastern markets, and also promoted Vermont as a tourist destination. For the convenience of local travelers, electric streetcar lines ran from Bennington to North Adams, Massachusetts; Hoosick Falls, New York; and the Vermont towns of Woodford and Glastenbury. The local railroads were plagued with financial instability and changed hands and names a number of times.

Wealthy Victorians traveled by railroad from Troy to their summer homes in Old Bennington and were later joined by the wealthy from New York City. Inns like the Walloomsac and Monument Inn catered to these high-class tourists. During the mid-1900s, more and more people had disposable income and free time to use it. The rise of the automobile and improved roads meant that even the middle class could take a Vermont vacation. Roadside cabin courts and motels with modest accommodations became enormously popular.

The roads in and around Bennington were still unpaved in the early 1900s and could be treacherous, particularly during winter and in the mountains. Covered bridges made river crossings safer in early days, but were gradually replaced by more modern structures during the 20th century. The covered bridges that remained became tourist attractions themselves for nostalgic travelers.

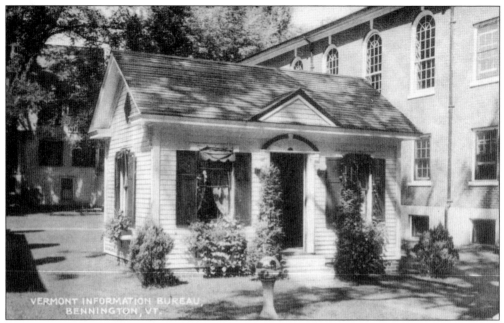

Tourist information could be obtained in this charming cottage that stood next to the courthouse on South Street until the 1950s. It was run by the Vermont Information Bureau and welcomed people coming into the state via Vermont Route 7. Today, a larger, more modern visitor center is open along the new and improved Route 7 to Manchester. (Courtesy of Beverley Petrelis.)

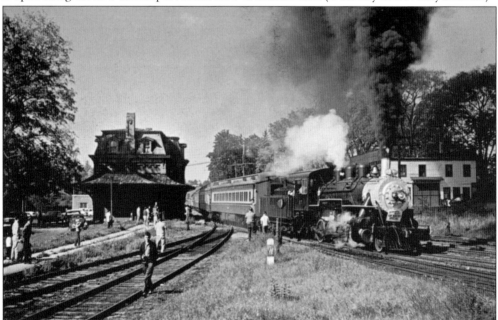

In 1880, Trenor Park, who had controlling interest in the railroad, urged the village of North Bennington to build this new station in the fashionable Second Empire style. During the mid-1960s, old steam engines began to provide tourists with train excursions through the county. The steam-powered Gay Nineties Special is leaving the North Bennington depot and heading east toward Shaftsbury, pulling several antique passenger cars. (Courtesy of Joe Hall.)

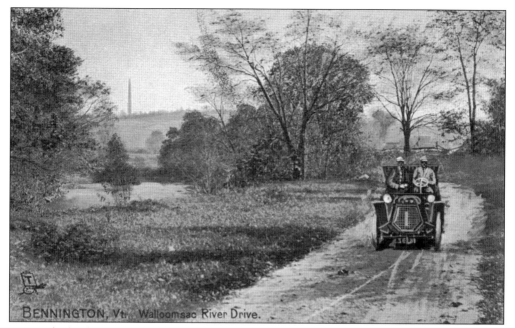

Postmarked July 20, 1908, this card has no message, but the caption on the back states that Walloomsac River Drive is "one of the favorite drives in which Bennington abounds." In 1908, automobiles were still a luxury, and scenic drives were a leisurely pastime only for the wealthy. The Bennington Battle Monument is in the distance, and this picture must have been taken near present-day Silk Road.

E.T. Griswold published a series of postcards promoting Bennington as a tourist destination, including this one of the "Western Gateway into Historic Bennington." The caption on the back states, "The highways from New York on the west and Massachusetts on the south which lead into Bennington are smooth and well graded, being built for many miles of concrete."

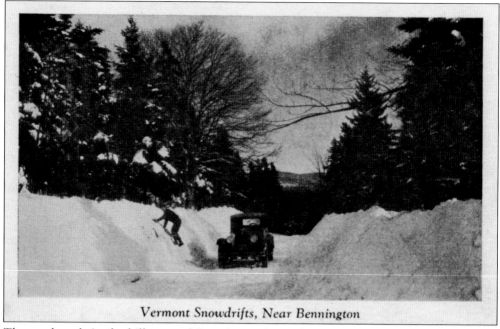

Vermont Snowdrifts, Near Bennington

The rural roads in the hills around Bennington have always been treacherous, especially in the winter. Woodford Mountain is particularly notorious for its snowfall. The car and person in this picture give some perspective as to the depth of the snow along the road near Alex Drysdale's camp.

In 1907, the road between Brattleboro and Bennington was unpaved, narrow, rutted, and twisting, with thick woods on either side. Even without snow, the section of road leading through Dunville Notch and up Woodford Mountain was dangerous.

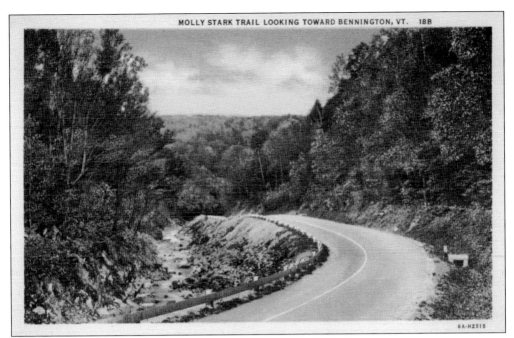

Even after the road was paved, this part of the Molly Stark Trail (Vermont Route 9) was considered one of the most dangerous sections because of its hairpin turn. City Stream is on the left and Harmon Hill is in the background. The road has been modified since 1945, when this card was mailed, to make it safer.

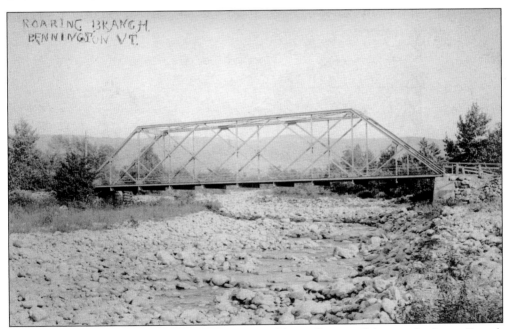

The Brooklyn Bridge spanned the Roaring Branch of the Walloomsac River at what is now Branch Street on the east end of County Street (the area was named Brooklyn by local residents). The bridge was replaced around 1960 by the current structure. The steel beams of the old bridge were used as the framework of the Morse Brick and Block factory at the bottom of Harwood Hill.

95

Hunt Street and Hicks Avenue were once connected by the Governor Robinson Bridge at the bottom of the golf course. Around 1920, the antiquated but picturesque covered bridge was replaced by a modern cement bridge—amidst protests from local residents. The highway was rerouted 20 years later. Alas, it was too late to save the bridge.

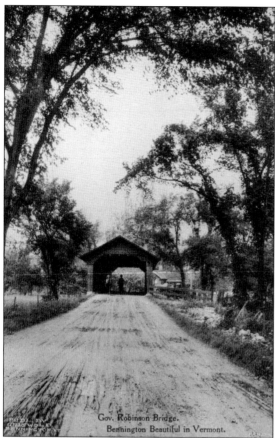

Gov. Robinson Bridge.
Bennington Beautiful in Vermont.

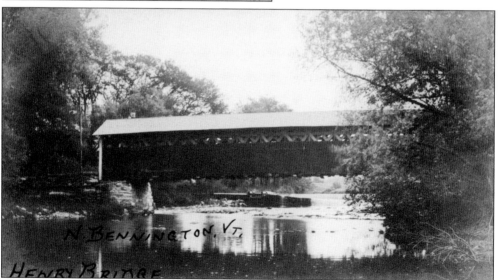

Before the Henry Bridge was built, the troops heading out to the Battle of Bennington forded the Walloomsac River at this spot. Later, the bridge was the main crossing for the wagons carrying iron ore from the Burden mines on Ore Bed Road to the foundry in Shaftsbury. The bridge was reinforced to bear the additional weight.

The main road from Old Bennington to Shaftsbury originally ran straight down the hill from the monument and crossed the Walloomsac through the Old Red Bridge. The road and the bridge no longer exist, yet modern GPS systems often suggest that drivers take this route. (Photograph by Frederick D. Burt.)

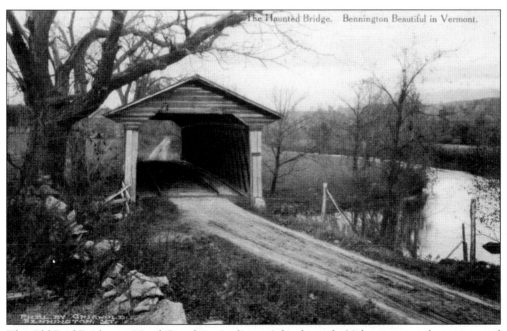

The Old Red Bridge on North Road was in disrepair by the early 20th century and was rumored to be haunted. According to the caption on the back of this card, "on certain moonlight nights weird noises are said to have been heard in and around it. A phantom horseman is frequently heard clattering across and into a nearby farmyard."

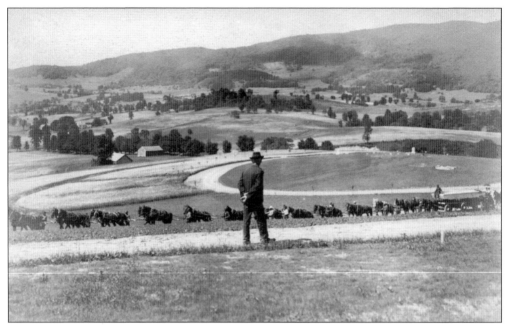

Horsepower was the best option available for transporting heavy loads short distances when Edward Everett's mausoleum was being built in the new Park Lawn Cemetery (organized in 1908). Twelve teams of horses were required to draw the massive capstone, said to be the largest block of granite ever shipped from Barre for mausoleum purposes.

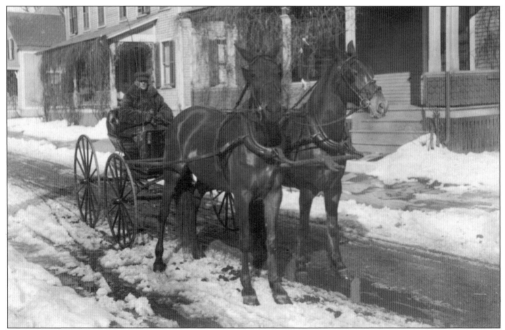

Harriet J. Sibley employed Clarence Wood as a handyman, a teamster, and as her chauffeur after she purchased a car. When this photograph was taken on Valentine Street, he was still driving her team of horses. Horse-drawn buggies were the most common way to get around town before the arrival of the automobile. (Courtesy of Joe Hall.)

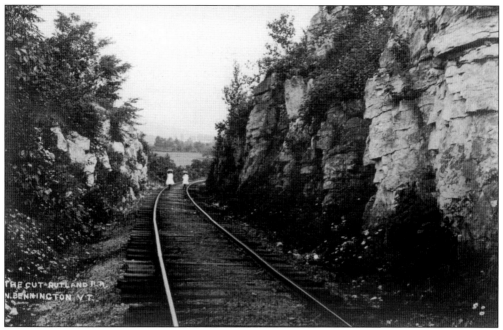

The Cut was an area in North Bennington where solid rocks had to be cut through to make way for the Rutland Railroad tracks. Lake Paran can be seen in the distance. The two children are identified on the back as Daniel Tompkins's girls, Helen and Hope, born in 1895 and 1897 respectively.

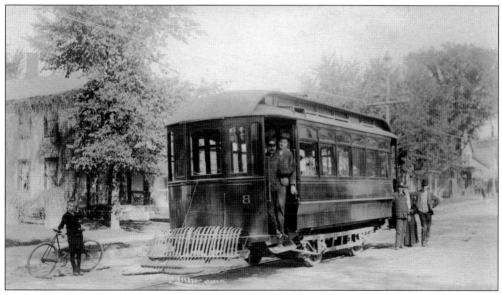

Trolley cars from the Bennington and Hoosick Falls Railway Company began regular service between the two towns in 1898. It took an hour and a half to make the 16-mile trip and cost 30¢. Trolley service lasted until 1927, when competition from automobiles combined with the terrible flood of 1927 put the company out of business.

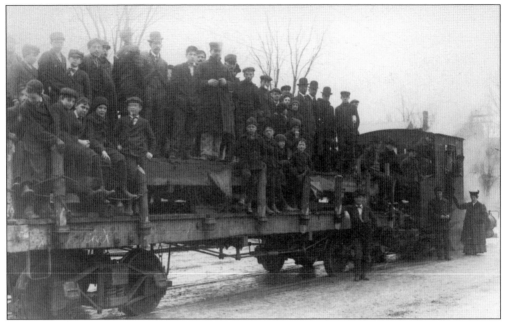

Labor problems, rock slides, and exceedingly cold weather plagued the crew working on the Bennington and North Adams Street Railway, but the men appear well bundled and happy as they stop for a photograph on East Main Street on December 21, 1906. Construction began on April 4, 1906, and was completed a little more than a year later. The company operated until 1929.

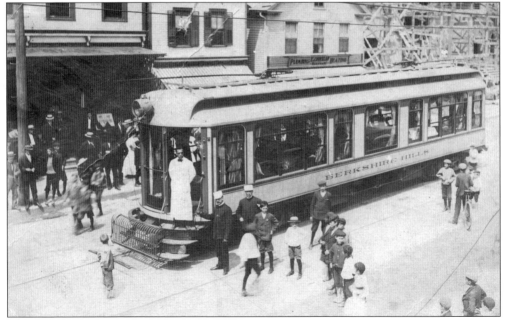

On June 27, 1907, the Bennington and North Adams trolley line opened to the public with much ceremony. Two cars, the *Berkshire Hills* (seen here) and the smaller car *Bennington* made two daily round-trips between Bennington and North Adams. Each round-trip covered 60 miles and took a little more than four hours to complete.

PHOTO BY F. D. BURT.

The Wason Car Company of Springfield, Massachusetts, built the Berkshire Hills as a private parlor car for its CEO in 1903, but it was relegated to public service by 1907. The car was considered the height of luxury and cost $20,000 to build. The interior featured Santo Domingo mahogany paneling, beveled glass mirrors between the windows, three ornate ceiling lamps, 32 electric heaters, a wall-mounted water cooler, an in-floor icebox, a carved mahogany desk, 28 upholstered wicker chairs, plush blue carpeting, and dark blue velvet drapes. The exterior was painted off-white with buff trim and gold striping and lettering. (Photograph by Frederick D. Burt.)

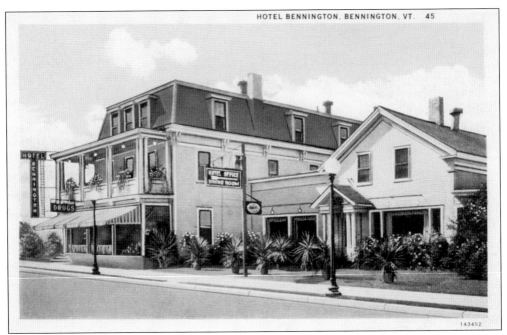

Just a block away from the railroad station, the Hotel Bennington welcomed guests on North Street. It had a dining room as well as a comfortable porch on which to relax and watch the passing traffic. The hotel had a pharmacy on the first floor, until a fire on New Year's Day 1934 put it out of business. (Courtesy of Beverley Petrelis.)

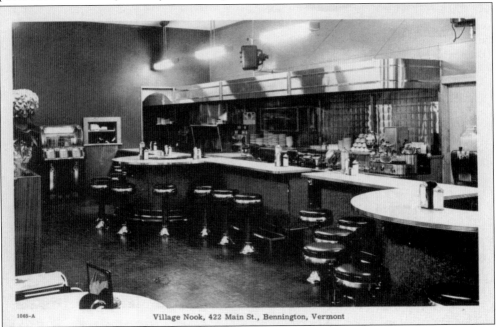

Village Nook, 422 Main St., Bennington, Vermont

The Village Nook on the north side of Main Street at 422 was one of downtown Bennington's most popular eateries after World War II. It featured both counter and table service and operated from 1946 into the early 1970s. Today, Madison Brewery occupies the same space. (Courtesy of Beverley Petrelis.)

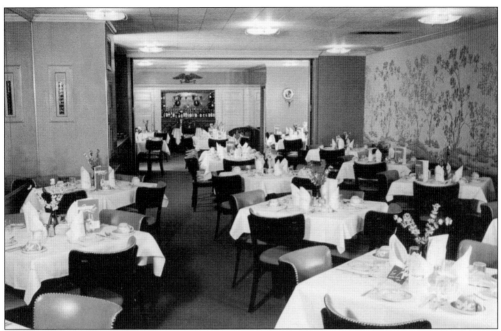

The Paradise Restaurant opened at 431 Main Street in 1927. It featured fine dining and elegant rooms, such as the Georgian Room on the second floor (above). The restaurant moved to 141 West Main Street (below) in 1962 after a fire at its original location. A Motor Inn was added to further accommodate tourists with 47 soundproof rooms, suites, a heated pool, private terraces with views of the Green Mountains, wall-to-wall carpeting, and "custom styled decor." The restaurant included a cocktail lounge, function room, and banquet facilities for up to 300. The building became the home of the Hagne Library of Northeastern Baptist College in 2013. (Both, courtesy of Beverley Petrelis.)

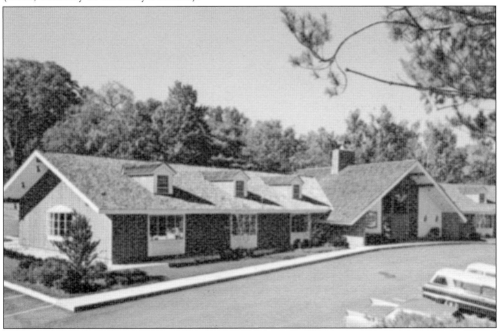

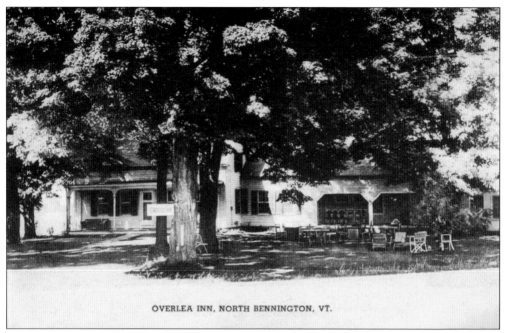

OVERLEA INN, NORTH BENNINGTON, VT.

Over the years, Marion E. Stanwood, proprietor of the Overlea Inn, provided lodging to the parents of many Bennington College students. At the junction of Matteson Road, Mechanic Street, and Overlea Road in North Bennington, it was a pleasant hostelry set back from the road with a spacious lawn and plenty of trees. (Courtesy of Joe Hall.)

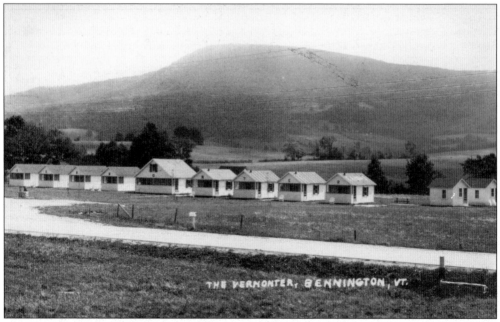

THE VERMONTER, BENNINGTON, VT.

Tourist cabins came into fashion with the popularity of the automobile in the mid-20th century. Cabin courts like the Vermonter, on West Road, offered basic accommodations within the budgets of most middle-class Americans. Individual cabins offered visitors privacy and easy access to their cars. (Courtesy of Joe Hall.)

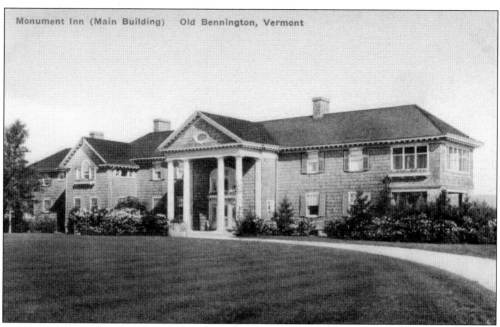

Monument Inn (Main Building) Old Bennington, Vermont

George and Mary Quackenbush of New York City built their summer home on 80 acres very close to the Battle Monument. In 1924, the house and furnishings were sold for approximately $75,000 to Samuel J. Keyes, who had plans to convert it into an inn. The newspaper reported that Keyes felt that "residents of the big cities are looking for the comparative retirement with high grade service that can be furnished on the property he has just acquired." The hotel opened the following year as the New Catamount Tavern (named after the Colonial-era hostelry). The name was later changed to the Monument Inn. The hillside north of the house was clear of today's trees and shrubs, offering a wonderful view (below). Today, the building is used by the Bennington School, a boarding school for troubled teens. (Above, courtesy of Beverley Petrelis.)

View of the Walloomsac Valley and Green Mountain from the Terrace Restaurant of Monument Inn Old Bennington, Vermont

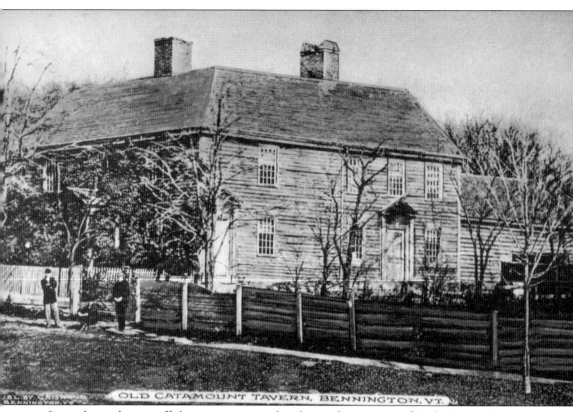

OLD CATAMOUNT TAVERN, BENNINGTON, VT.

Legend says that a stuffed catamount was placed atop the signpost of Fay's Tavern, "grinning defiance" toward New York, by the New Hampshire grantees during the conflict over rights to the land that is now Vermont. Ethan Allen lodged at the tavern when he first came to Bennington, and he chose it as the headquarters for the Green Mountain Boys. It was in the council room of this tavern that the Green Mountain Boys met with Allen to plan the daring attack on Fort Ticonderoga in May 1775. The Council of Safety gathered here before the Battle of Bennington along with the local militia, and Vermont's General Assembly met in the tavern in 1778. A stuffed wildcat could not have lasted long while exposed to the elements, but the story of the fierce catamount grinning defiantly toward New York became legend, and the name Catamount Tavern stuck to the building long after it ceased operation as an inn. The building burned to the ground on March 30, 1871.

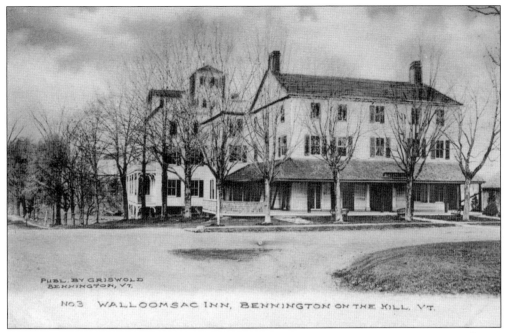

PUBL. BY GRISWOLD
BENNINGTON, VT.

NO 3 WALLOOMSAC INN, BENNINGTON ON THE HILL. VT.

Built in 1766 by Capt. Elijah Dewey, the Walloomsac Inn is now a private home, but when it closed in 1987 it was the oldest running inn in Vermont. Its kitchens are said to have supplied food for the soldiers who fought in the Battle of Bennington. Walter Berry purchased the building in 1891 and ran it as a summer inn, catering to the wealthy of Troy, New York.

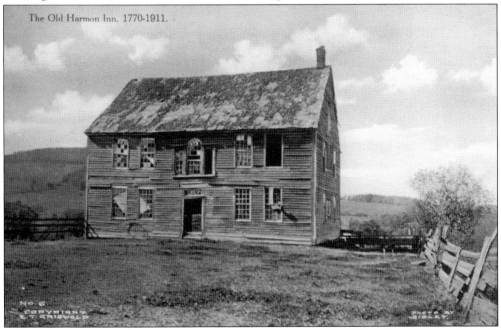

The Old Harmon Inn, 1770-1911.

The Harmon Inn was built in 1765 and stood near the corner of Vail and Airport Roads. Supposedly, Gen. John Stark and his staff ate dinner here while en route to the Battle of Bennington in 1777. At the time, it was one of seven taverns in town, but by 1900 it was in ruins. It was finally torn down in 1911. (Photograph by W.H. Sibley.)

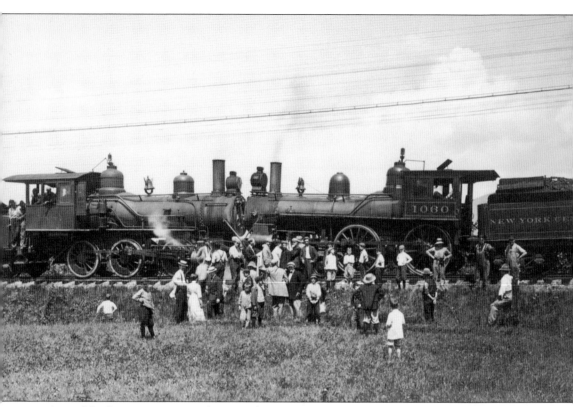

A terrible disaster was narrowly averted August 11, 1910. Three boys sitting on a fence near the train tracks just north of the Soldiers' Home noticed the 12:15 passenger train from Troy coming around a bend, about to collide head-on with the Extra Freight coming from Rutland. The boys were able to signal to the conductor of the freight train to slow down, which he did, coming to a rapid stop before colliding with the passenger train. According to the write-up in the *Bennington Banner* later that day, about 18 passengers were "badly shaken up and frightened but otherwise unhurt." The passenger train engine (on the right) was partially derailed, and the engines interlocked in the crash. It took a local crew two and a half hours to disengage them. (Photograph by Frederick D. Burt.)

Seven

Disasters, Both Natural and Unnatural

Railroads and automobiles introduced the town of Bennington to train and car accidents. Some of Bennington's accidents have been minor, but others were truly disastrous.

Before automation or modern communication technology, human error often had tragic results on the railroads. Train conductors could telegraph if they were running early or late, but if their view was obstructed or if they miscalculated or misunderstood information relayed to them, a locomotive weighing many tons could do an awful lot of damage before coming to a stop. In 1900, there were only around 8,000 automobiles in the entire United States. By 1920, there were 7.5 million. The first car fatality in Bennington was only a matter of time.

Bennington has endured its share of natural disasters, such as fires, floods, and even hurricanes. Floods can be a particular problem in Vermont when large amounts of rain run off steep mountainsides into streams and rivers that are unable to deal with the volume. Thus, hurricanes can cause massive damage to this landlocked state (Hurricane Irene in 2011 is the most recent example). Vermont's worst natural disaster was caused by a hurricane in 1927, which dropped four to nine inches of rain on already saturated ground. Roads around Bennington were completely washed out, and an incredible amount of damage was done to local homes, businesses, and utilities. The flood also washed away trolley tracks, ending service for good in some cases.

Lack of water has also caused problems in the case of fires. Since the village of Old Bennington is located on a hill, there is little water pressure, which made it difficult for firefighters battling the blaze at the Jennings estate in 1910.

Vermonters always seem to survive, and even come out ahead after disaster strikes. Roads and bridges were rebuilt and modernized after the 1927 hurricane and after Irene. Buildings lost to fire have been reconstructed, and, in some cases, expanded and improved.

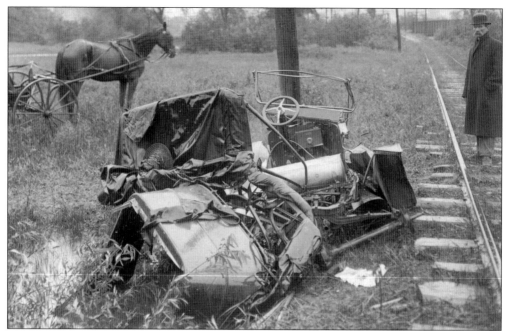

On May 30, 1910, one of the first fatal automobile crashes in Bennington occurred when the car of William D. Newton of Union Street was destroyed by a trolley car near the junction of Benmont Avenue and Hunt Street. The accident made the *New York Times*, which reported, "A driving rainstorm that obscured the view of an automobile driver and an electric car motorman to-day caused a collision, in which Henry L. Knapp . . . was killed, and his companion, Miss Kate McGuire, . . . a cousin of Knapp, and William Newton, a local garage keeper, and owner and driver of the machine, were seriously injured and may die." Newton, who owned a hardware store at the corner of Main and Silver Streets, had just received the new Ford Model T from the factory. He and the other three passengers did survive.

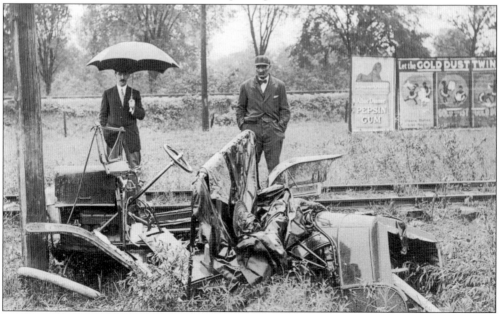

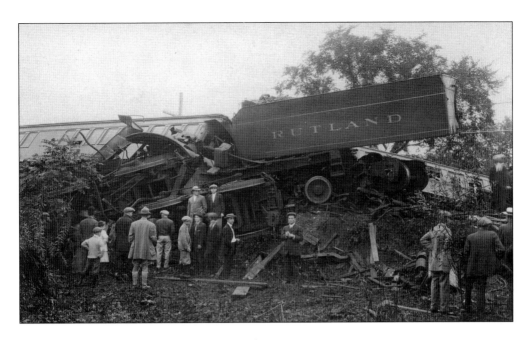

On September 7, 1912, the train bringing milk from Vermont dairy farmers to New York City was nearly two hours late leaving Rutland. The engineer was instructed to travel at as high a speed as he felt was safe. The southbound milk train was traveling at 45–50 miles per hour when it collided with a northbound passenger train near the Vermont Veterans' Home at 7:50 p.m. According to the *Bennington Banner*, "When the trains came together the larger milk train locomotive . . . pushed the smaller passenger train engine back, turning it almost completely in the opposite direction and tipping it over, exploding the boiler. The larger locomotive also tipped over on the same side of the tracks." Both trains were completely destroyed in what was one of the worst train wrecks in Bennington's history. (Below, courtesy of Joe Hall.)

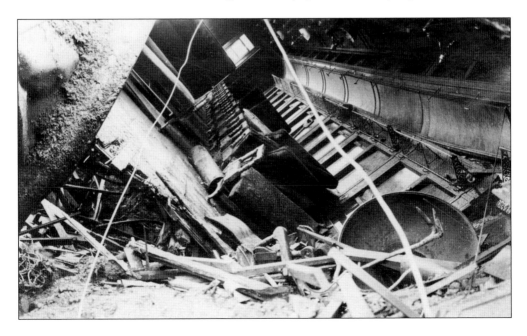

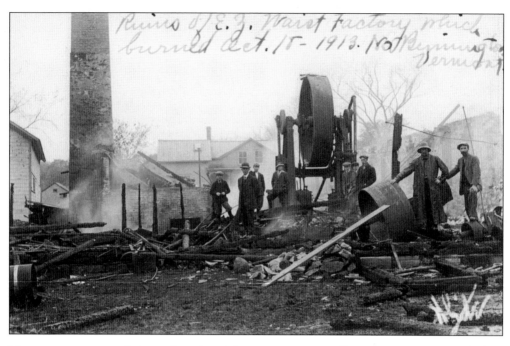

Fires were a constant threat to Bennington's economy. E-Z Mills employed nearly 200 people manufacturing children's knit underwear in its factory in North Bennington (below). On October 18, 1913, the mill on Sage Street caught fire and burned to the ground (above). Only the tall chimney on the left remained standing. When the mill was rebuilt at the same location by A.S. Payne, the chimney was incorporated into the new structure. The site is now used by the Vermont Arts Exchange as a studio and performance space. (Above, photograph by Wills T. White; below, courtesy of Joe Hall.)

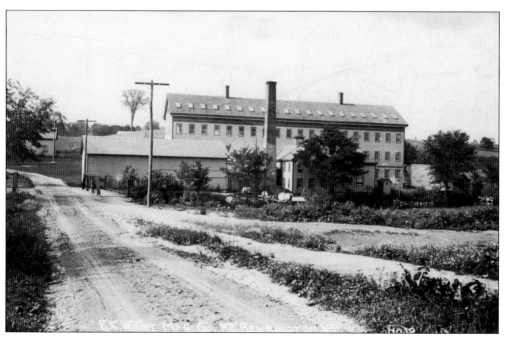

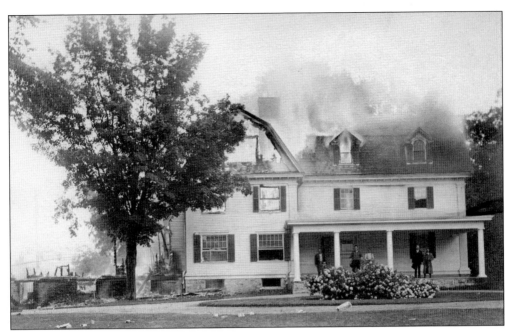

The home of Philip B. Jennings, a prominent Bennington businessman, was completely destroyed by a fire that engulfed the building August 11, 1910. The fire appeared to have started in the basement laundry room and was blamed on an electric iron that had been left unattended by one of the maids. The fire moved through the house slowly enough that most of the furnishings were removed safely and for five men to pose on the porch for the photographer. Following the building's destruction, Jennings built a new house (below) and lived there until his death in 1949. That building is now the Four Chimneys Inn. (Above, photograph by Frederick D. Burt; below, courtesy of Joe Hall.)

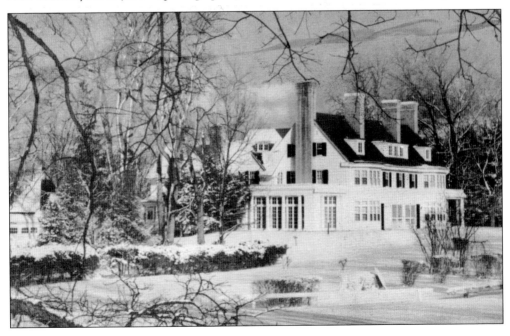

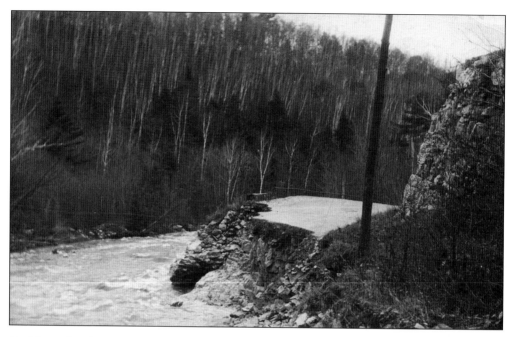

On November 2-4, 1927, a hurricane dropped between four and nine inches of rain on Vermont. A rainy October meant the ground was already saturated and the rivers full. The result was the worst natural disaster in Vermont's history. Statewide, the flood washed away 1,285 bridges and countless miles of roads and railroad tracks. Eighty-four people, including Lt. Gov. S. Hollister Jackson, died in the resulting floods that destroyed hundreds of homes and businesses. In Bennington, Woodford Road, the current Vermont Route 9, was washed out entirely except for small patches (above). The electric transformer station (below) was critically damaged and partially collapsed into the raging river.

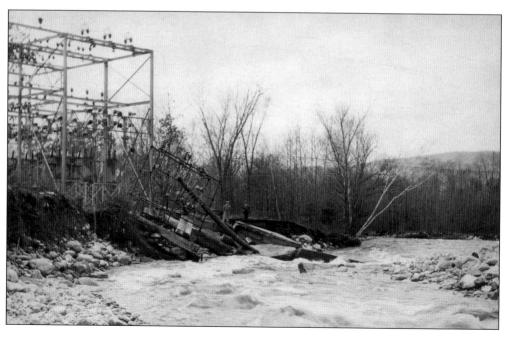

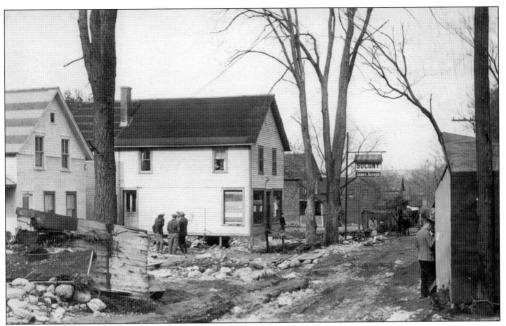

North Branch Street was completely washed out during the flood of 1927. The inscription on the back of this card reads, "This was taken long after things were cleaned up. When I was here the water was still running wildly across the road. Andy's car and garage in the right hand corner washed to the opposite side from where it was."

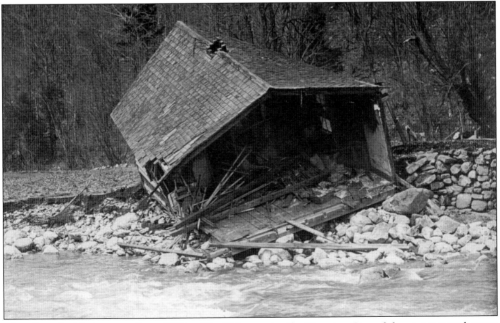

Usually a placid river coming off Woodford Mountain, the Roaring Branch becomes treacherous at flood stage, as illustrated in this postcard of flood damage in 1918. While the waterway is flooding, the sound of boulders tumbling against each other can be heard miles away, and the force of the water can demolish the sturdiest buildings.

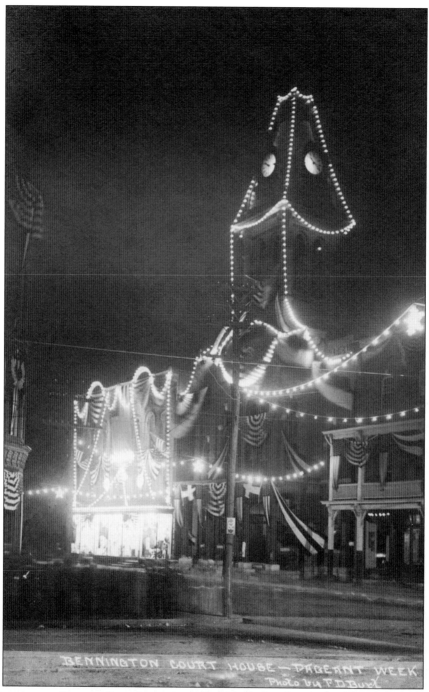

BENNINGTON COURT HOUSE — PAGEANT WEEK
Photo by F.D.Burt

The Bennington County Courthouse is outlined in lights during the 1911 sesquicentennial anniversary of the settlement of Bennington. Strands of electric lights decorated many buildings in the downtown business district and were draped across the principal roads. Electricity became available in Bennington in 1887 when the village contracted with the Bennington Electric Light and Power Company to provide 40 streetlights to be illuminated from dusk until midnight. (Photograph by Frederick D. Burt.)

Eight

PARADES AND
CELEBRATIONS

Vermont has its very own state holiday commemorating the Battle of Bennington, fought August 16, 1777. In the town of Bennington, Battle Day is celebrated with a parade, often featuring scores of fire trucks from all around the region. Important events were often scheduled to coincide with Battle Day, including the laying of the cornerstone of the Putnam Memorial Hospital in 1916. In 1911, the town celebrated the 150th anniversary of its settlement with an entire week in August dedicated to the celebration, culminating in a historical pageant illustrating the history of the town. Scenes included New Hampshire governor Benning Wentworth (for whom Bennington is named), the arrival of early settlers, conflicts between the New Hampshire grantees and "Yorkers," and, of course, the Battle of Bennington. The pageant involved the entire community, with many parts being played by the descendants of original settlers.

Of course, Bennington also celebrates the Fourth of July with parades and picnics, as it is celebrated throughout the country. In the 1910s, the village of North Bennington held its own Fourth of July parade with a number of elaborate floats and marchers from the local mills.

A sense of community was fostered by the Bennington Civic Society, which spearheaded an effort to provide entertainment opportunities for local youth. It organized regular plays, dancing shows, athletic contests, and other events. There was concern in the early 1900s that children would grow up and move to larger cities where there was more going on, leaving an aging population without much hope of renewal. Through a community-sponsored playground near the corner of Depot and North Streets and regularly scheduled activities, the Bennington Civic Society hoped to keep youth satisfied at home and occupied by "wholesome" activities that were designed to mold them into responsible and productive members of society.

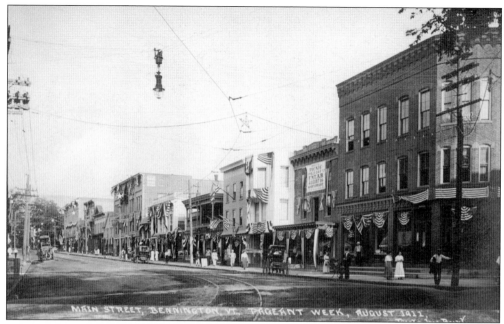

Bennington decked Main Street with flags and bunting for Pageant Week, August 12–16, 1911, when the town celebrated 150 years of settlement. The string of electric lights above the street with a star in the center was illuminated at night. The large sign hanging from the building on the right advertises a picnic held by the Father Matthew Total Abstinence and Benevolent Society. (Photograph by Frederick D. Burt.)

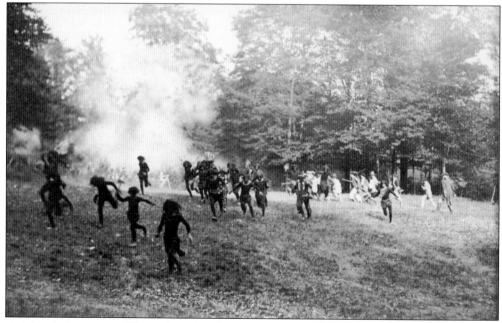

A historical pageant illustrating the history of Bennington was the highlight of the sesquicentennial celebration. Native Americans fighting with the British were portrayed by young men in blackface.

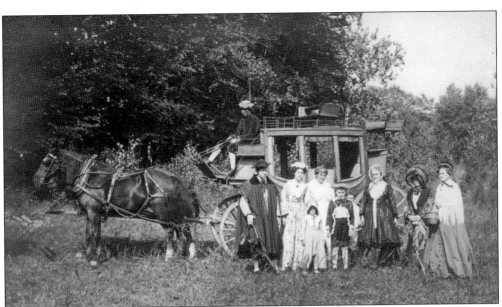

These two postcards show additional scenes from Bennington's 1911 sesquicentennial pageant. A stagecoach was borrowed from Greenfield, Massachusetts, to illustrate a scene at New Hampshire governor Benning Wentworth's mansion in Portsmouth, New Hampshire (above). Like the costumes, the stagecoach was old, but not quite historically accurate. Wentworth granted the town charter in 1749, ignoring the fact New Hampshire's western boundary with New York was disputed. In the 1760s, New Yorkers tried to assert their own rights to what is now Vermont. While politicians tried to settle competing claims diplomatically, Ethan Allen took the law into his own hands and started intimidating "Yorkers" with his band of Green Mountain Boys. The reenactment below shows New York sympathizer Dr. Samuel Adams being hoisted up the signpost for the Catamount Tavern, tied to an armchair. (Above, photograph by Frederick D. Burt.)

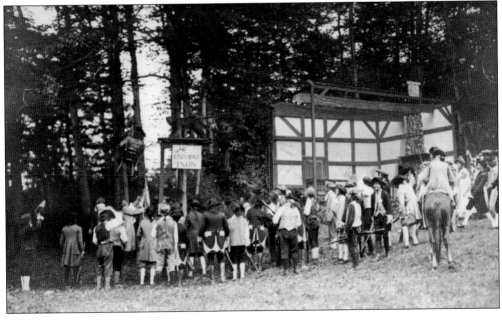

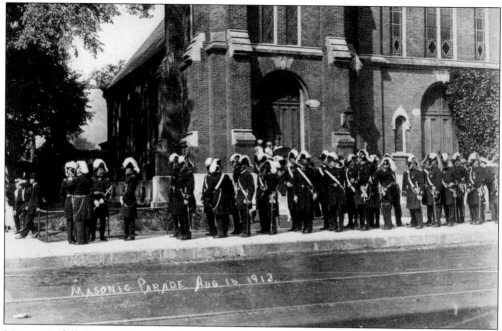

Masons in full dress uniform lined up to march in the annual Battle Day Parade on August 16, 1912. They are assembled in front of the Second Congregational Church on Main Street, which was located next door to the Masonic Hall. (Photograph by L. DeForest Cone.)

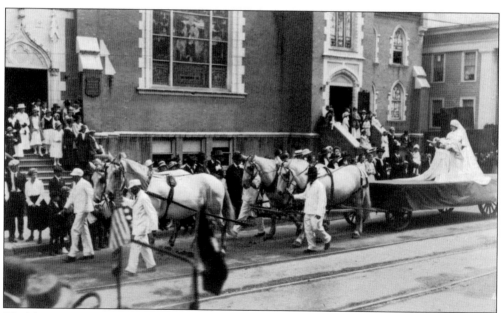

World War I was raging in Europe on July 4, 1917, and the United States had only recently joined the fighting. This float was inspired by a Red Cross poster titled "The Greatest Mother in the World" and depicts a woman holding a representation of a wounded soldier. The image evokes the Virgin Mary cradling the dead Christ, making a powerful connection between ordinary women and extraordinary deeds.

120

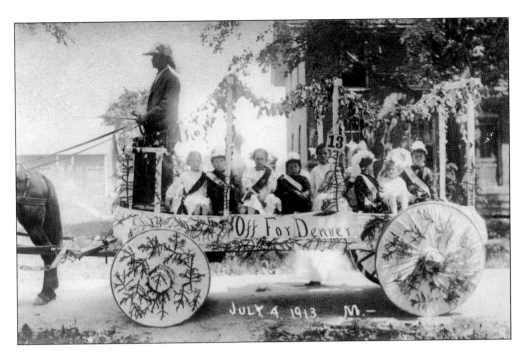

North Bennington's 1913 Fourth of July parade included a float with the slogan "Off to Denver" (above). The Industrial Workers of the World labor union was fighting in Denver that year for the right to speak on the street to organize factory workers. Since North Bennington was an industrial town at the time, this float might be a show of solidarity with the union's efforts. The group of women wearing hats labeled "E-Z" are workers from the nearby E-Z Mills (below). Many of the textile mills in town were staffed by more women and children than men. (Below, courtesy of Joe Hall.)

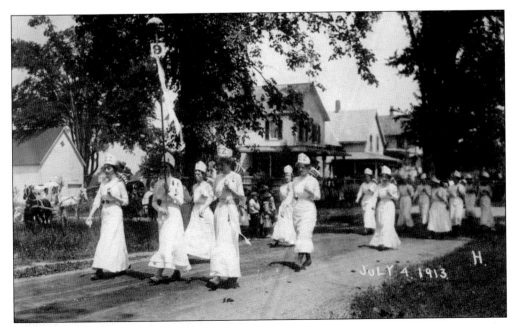

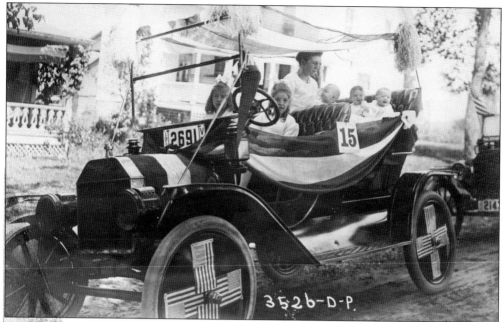

Alonzo Remington drove his Ford Model T in North Bennington's 1914 Independence Day parade to show off his grandchildren. His daughter, Eliza Remington Woodhull, wife of Dr. Joel Brown Woodhull, sits in the back with her triplets born earlier that year—James, Josephine, and Joanna. Seated in the front seat are the triplets' older sister, Leola (left), and their neighbor Adeline Ripley (right).

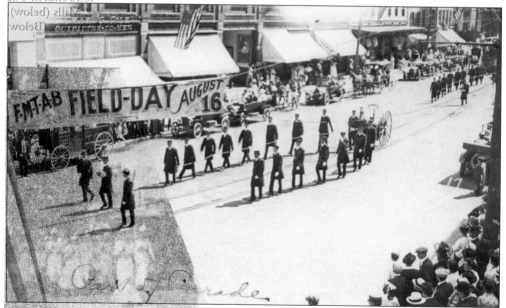

These firefighters are pulling a hose cart (an antique even then) in the 1916 Bennington Battle Day parade. The banner in the foreground advertises a field day being held by the Father Matthew Total Abstinence and Benevolent Society of Bennington. FMTAB was an international organization advocating total abstinence from alcohol, with a large following in Bennington. The 1916 picnic featured boxing, a vaudeville show, a live orchestra, and dancing.

Laying the cornerstone of the Putnam Memorial Hospital was scheduled to coincide with Bennington Battle Day August 16, 1916. A two-mile parade including numerous local dignitaries wound its way from Main Street to the hospital grounds (right). Exercises on the grounds were under the charge of the grand officers of the Grand Masonic Lodge of Vermont (below). A copper time capsule inside the cornerstone was filled with letters relating to the building of the hospital, copies of the *Bennington Banner* newspaper, and photographs of Henry W. Putnam Jr. breaking ground. The hospital was given to the town by Putnam in memory of his father, Henry W. Putnam Sr.

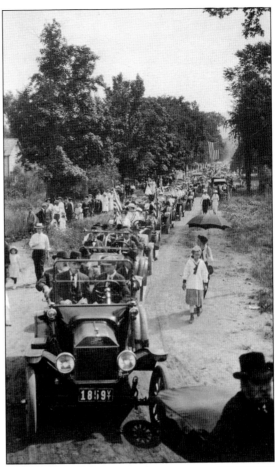

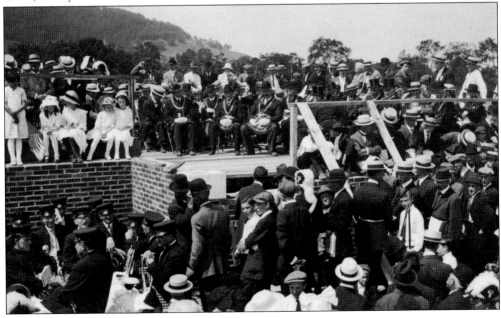

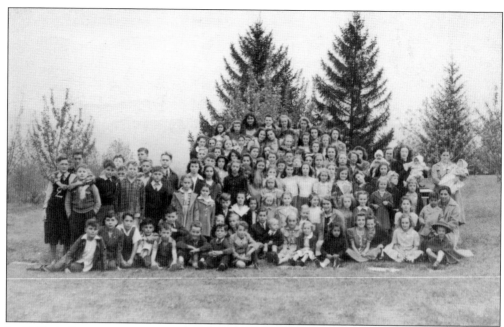

In 1942, the Putnam Memorial Hospital hosted a reunion of children who had been born in the hospital since it opened in 1918. A maternity department was among the first additions to the hospital through the generosity of Henry Putnam Jr. The children in this photograph would only have been a small fraction of those born up to that time.

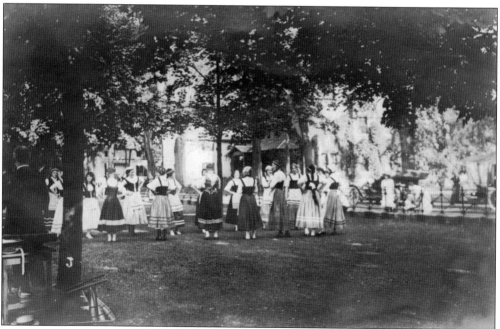

A folk dance festival in 1913 was the culmination of efforts by the Civic League to promote folk dancing as healthy exercise and an "exercise in rhythmical beauty." The league held weekly folk dancing classes for young women and girls. (Photograph by L. DeForest Cone.)

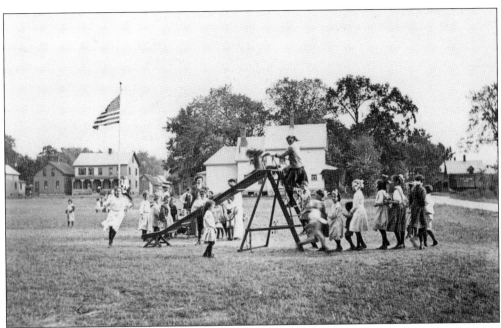

Wholesome entertainment for young people was a growing concern in the early 1900s. A playground was constructed with public funds in 1910 under the auspices of the Civic League, a branch of the Village Improvement Society. The following year, the town agreed to pay for a trained supervisor of recreation, who organized games, exercise classes, and public performances. Grand festivities accompanied the annual opening and closing of the playground near the corner of Depot and North Streets (an invitation postcard to the 1911 season opening is seen above). The Civic League sponsored sporting events at the playground, including volleyball, baseball, hockey, and basketball. The Fourth of July 1913 was celebrated with footraces (below). (Photographs by L. DeForest Cone.)

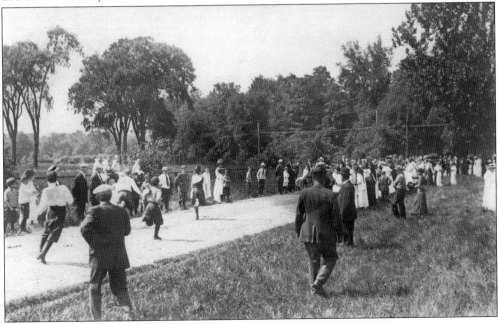

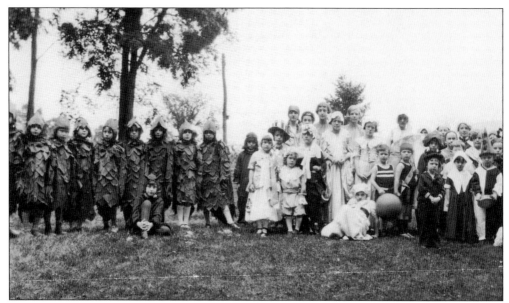

Children in a variety of costumes marched around the green in front of the Old First Church in a "Kiddie Parade" that was the big attraction at the street fair held September 3–4, 1926. The fair also featured floral displays and booths selling food, candy, antiques, gifts, cigarettes, puppies, and pigs, as well as music and dancing at night. The fair raised $3,000 for the Girls Club.

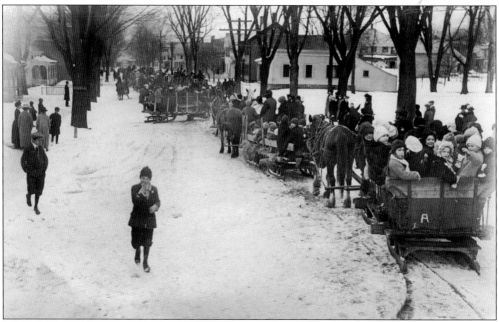

All the children of Bennington were invited for a community sleigh ride on March 9, 1914. According to the local paper, every team of horses and sleigh or box on runners in town was pressed into service for the event. Merchants provided a bag of candy for each participant, and the Bennington Band led the procession. (Photograph by L. DeForest Cone.)

A cold but enthusiastic crowd of about 1,200 gathered in front of the Graded School for the lighting of Bennington's Community Christmas Tree in 1914. In an effort to stay warm enough to perform, Bennington's brass band was situated in a first-floor schoolroom with the windows open for the crowd outdoors. The cold was so intense that the bandleader's cornet froze anyway, delaying the festivities. The tree was illuminated with strings of electric lights and a large star at the top. In addition to putting up the Christmas tree, the Civic League worked with Bennington teachers to have local children write letters to Santa Claus as an exercise in English composition. They then arranged for charitable donations of shoes, clothing, toys, and food to the less fortunate, based on the letters. (Photograph by L. DeForest Cone.)

Discover Thousands of Local History Books Featuring Millions of Vintage Images

Arcadia Publishing, the leading local history publisher in the United States, is committed to making history accessible and meaningful through publishing books that celebrate and preserve the heritage of America's people and places.

Find more books like this at
www.arcadiapublishing.com

Search for your hometown history, your old stomping grounds, and even your favorite sports team.

Consistent with our mission to preserve history on a local level, this book was printed in South Carolina on American-made paper and manufactured entirely in the United States. Products carrying the accredited Forest Stewardship Council (FSC) label are printed on 100 percent FSC-certified paper.

MADE IN THE USA